IN FOCUS

DORIS ULMANN

PHOTOGRAPHS

from

THE J. PAUL GETTY MUSEUM

The J. Paul Getty Museum

Malibu, California

In Focus
Photographs from the J. Paul Getty Museum
Weston Naef, *General Editor*

© 1996 The J. Paul Getty Museum
17985 Pacific Coast Highway
Malibu, California 90265-5799

Christopher Hudson, *Publisher*
Mark Greenberg, *Managing Editor*

Library of Congress
Cataloging-in-Publication Data

Ulmann, Doris, d. 1934.
 Doris Ulmann : photographs from the J. Paul
Getty Museum.
 p. cm. — (In focus)
 ISBN 0-89236-373-8
 1. Photography, Artistic. 2. Ulmann, Doris,
d. 1934. 3. J. Paul Getty Museum—Photograph
collections. 4. Photograph collections—
California—Malibu. I. J. Paul Getty Museum.
II. Title. III. Series: In focus (J. Paul Getty
Museum)
TR653.U44 1996
779′.092—dc20 95-41084
 CIP

Contents

Foreword

For this volume in our In Focus series devoted to photographers well represented in the Getty Museum's collection, a lesser-known figure has been chosen, Doris Ulmann, whose work nevertheless deserves a wider public. Beyond having made a large body of accomplished pictures, Ulmann is a fascinating figure for several reasons. One is her collaboration with the folklorist John Jacob Niles, with whom she explored the rural South, recording music, promoting crafts, and making a visual record. This creative relationship of two strong partners resembles that of Georgia O'Keeffe and Alfred Stieglitz and a few other celebrated pairs, Tina Modotti and Edward Weston, Dorothea Lange and Paul Taylor, and Margaret Bourke-White and Erskine Caldwell. Ulmann was patron as well as artist; Niles served as model, muse, archivist, and envoy.

This partnership, as well as Ulmann's own achievement, was discussed in a lively colloquium held at the Getty Museum on November 16, 1994. The participants included William Clift, Weston Naef, Ron Pen, and Susan Williams as well as Judith Keller, who organized the event; Charles Hagen, who moderated it; and David Featherstone, who condensed the daylong conversation into a readable text. To all of them I am grateful.

I want especially to thank Judith Keller for her role in managing this project as well as for the texts opposite the plates. Others at the Getty Museum assisted, particularly Michael Hargraves, who provided research and logistical help, and Julian Cox, Stepheny Dirden, Quinten Garth, Marc Harnly, Andrea Leonard, Ernest Mack, Charles Passela, Ellen Rosenbery, Jean Smeader, Sarah Sullivan, and Rebecca Vera-Martinez. During the preparation of the book, various kinds of useful information about Ulmann and her art were contributed by Beverly Brannan, Ken Breisch, John Hawk, Michelle Lamunière, Melissa McEuen, Sarah Morthland, Mary Panzer, Sally Stein, and Alicia Wille, whom I am glad to thank.

John Walsh, *Director*

Introduction

The life and work of the American photographer Doris Ulmann (1882–1934) reflect many of the sometimes contradictory developments of the first decades of the twentieth century. Ulmann was caught between what the cultural historian Ann Douglas has described as the dying feminine culture of the Victorian reform movement and the emerging masculine culture of prosperous, mass-media modernity. Technology and industrialism were worshipped, while at the same time the archaic and the handmade were encouraged (Henry Ford built Greenfield Village; John D. Rockefeller, Jr., restored Williamsburg). As the United States became more urban, the rural was revered more than ever. In the period that sent a new wave of anthropologists, such as Margaret Mead, to Africa and the South Pacific in search of the "authentic," a new nativism, which held up the South as the stronghold of pure American stock, began to thrive. The preservation of traditional American crafts, music, and folklore, and the recording of their practitioners, took on a sense of urgency. Black folklife, rapidly being altered by the Northern migration of African Americans, was in particular need of documentation.

Ulmann was perhaps an unlikely person to work in the rural South. Born in New York City, the eldest daughter of a prosperous German-Jewish father and American mother, she attended the Ethical Culture School, studied psychology at Columbia University just as Sigmund Freud was becoming known in America,

and came under the influence of photographer Clarence H. White. Early in the second decade of this century she married the surgeon Charles Jaeger, who shared her enthusiasm for amateur photography. She began her career as a studio portraitist, photographing and publishing pictures of notables from the worlds of medicine, journalism, and the arts. Her Park Avenue apartment, located just two blocks from the Metropolitan Museum of Art, became the setting for an extended series of photographs of these "urban moderns."

In the mid-1920s Ulmann divorced Jaeger and met John Jacob ("Jack") Niles, a musician and actor ten years her junior who became her close friend and assistant. Together they began to document the culture of the American South. "Folklore and photographic expeditions" was the way Niles described the extensive, annual car excursions he and Ulmann made between 1928 and 1934 in the Southern Highlands, that area of the Appalachian Mountains that extends from the Virginias down into Georgia and Alabama. Niles's interest in seeking out the musicians and ballad singers of Appalachia overlapped with the mission of the rural settlement schools that were often the destination and operating base for the Ulmann/Niles forays. These schools had grown out of the anti-industrial ideals of the Arts and Crafts movement and were intended to bring education and vocational training to the poor. They also reinstituted the practice of local craft traditions. In 1933 and 1934, having put themselves at the service of Allen Eaton, who was preparing a book on the subject, Ulmann and Niles recorded in a more systematic way the character and handwork of the Highland craftspeople. Ulmann collaborated as well with the novelist Julia Peterkin, producing *Roll, Jordan, Roll* (1933), an overview in expository prose, fiction, and photographs of the vanishing black Gullah culture of South Carolina.

The technical aspects of Ulmann's art were slightly old-fashioned. In the teens, following the painterly Pictorialist style still in vogue, she created a number of her portraits, genre studies, and landscapes in the gum bichromate and bromoil printing media. The bulk of her images, however, were platinum contact prints produced using glass-plate negatives in a 6 1/2-by-8 1/2-inch view camera. Exposures were made without a light meter, and the prints were often finished with a waxed or varnished surface. Although it saw little action, an 8-by-10-inch view camera accompanied her during her travels in the 1920s and 1930s, well

after fast, hand-held cameras like the Leica had reached the market and become the favored tools of photojournalists.

Unfortunately, many negatives from the last months of Ulmann's life remained undeveloped and unprinted at the time of her death. Another New York photographer, S. H. Lifshey, was engaged by the Doris Ulmann Foundation to develop and print this remaining material (albeit on a warm gelatin silver Gevaert paper meant to resemble platinum) and to produce proof prints from thousands of other negatives in her studio so that a visual archive of her work would be preserved. Berea College in Kentucky, which received an endowment from Ulmann for a photography gallery, was the recipient of some 3,000 posthumous prints. A gift of 110 original platinum prints was made to the Library of Congress, which had earlier purchased a group of her pictures, and Niles received a large number of prints as well as musical instruments Ulmann had acquired.

The negatives, nearly 3,000 platinum photographs, and eighty-three posthumous proof-print albums containing approximately 9,000 images languished at Columbia University until the 1950s, when the university asked that they be removed. The Ulmann Foundation found a home for a fraction of the negatives (about 7,000 were destroyed), the proof-print albums, and about 150 platinum prints in the Special Collections department of the University of Oregon Library. The bulk of the foundation's holdings, which included hundreds of New York studio portraits in addition to images from the Southern expeditions, went to the New-York Historical Society, which remains the most important East Coast resource for the study of Ulmann.

In the summer and fall of 1974, Samuel Wagstaff, Jr., purchased 8 Ulmann prints, which probably came from the group inherited by Niles, from the Witkin Gallery in New York. Ten years later these prints became the core of the Getty Museum's Ulmann collection. They were supplemented in 1987 when, at the recommendation of Weston Naef, the Museum acquired 159 prints from Niles's heirs, including 21 studies of Niles. In recent years, several rare images have been added, bringing the Museum's holdings to the current 171 photographs from which the plates reproduced in this book were chosen. Aside from the major institutional holdings mentioned above, Ulmann's work can be studied in large numbers at the Schomburg Center for Research in Black Culture (New York), the

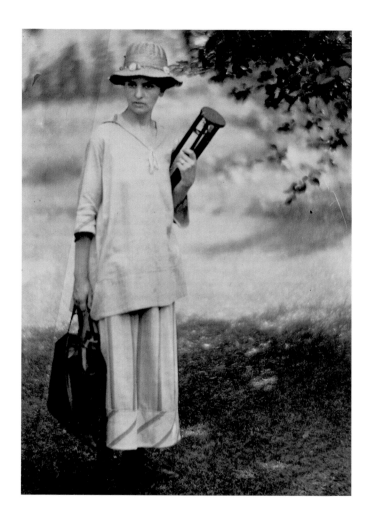

Attributed to John Jacob Niles. *Doris Ulmann,* circa 1934.
Gelatin silver print, 20.9 × 15.9 cm.
Special Collections, University of Oregon Library,
Doris Ulmann Collection no. 7677.

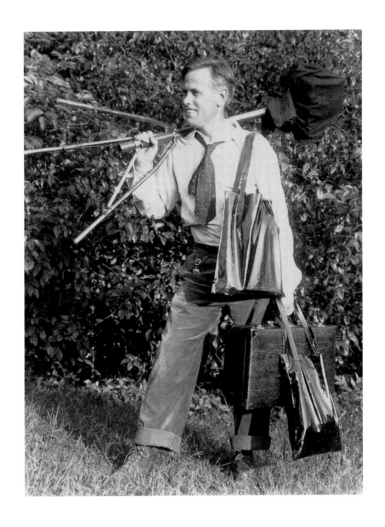

Doris Ulmann. *John Jacob Niles,* circa 1934.
Gelatin silver print, 20.3 × 15.2 cm.
87.XM.89.22.

South Carolina Historical Society (Charleston), the International Museum of Photography at George Eastman House (Rochester, New York), the University of Kentucky Art Museum and the King Library (Lexington), and the Australian National Gallery (Canberra).

Several of the participants in the 1994 colloquium on Ulmann's life and work pioneered the serious study of her photography, bringing her images to the public eye in the 1970s and 1980s. William Clift, a photographer based in Santa Fe, first encountered Ulmann's work in 1964 near Boone, North Carolina, while traveling on the Blue Ridge Parkway. His intense admiration for her work resulted in the 1974 Aperture publication *The Darkness and the Light.* David Featherstone, an independent editor and curator, became acquainted with Ulmann's pictures while he was a graduate student at the University of Oregon. He pursued her biography for more than ten years, completing *Doris Ulmann, American Portraits* in 1985. Ronald Allen Pen, Associate Professor and Associate Director of the School of Music at the University of Kentucky, is both a performer and scholar of folk music. He has written extensively about Niles and is presently preparing his biography. Susan Millar Williams's research into American literature has centered on Southern women authors, particularly, in recent years, on Peterkin's life and writing. Her biography of Peterkin, tentatively titled *White Woman Writer,* is forthcoming. Ms. Williams resides in South Carolina, where she is currently Director of the McClellanville Arts Center. Charles Hagen, an art critic for the *New York Times,* served as the colloquium moderator, as he has for previous In Focus discussions.

Judith Keller, *Associate Curator, Department of Photographs*

Plates

A Note about Dimensions

Plates identified as gelatin silver were printed post-humously between 1934 and 1937. These pictures remain mounted in their original window mats, which conceal the edges of the prints, so dimensions given for them are approximate.

PLATE 1

PLATE 2

PLATE 3

Harbor Scene,
Probably Gloucester,
Massachusetts

Circa 1916–25

Platinum print
20.4 × 15.5 cm
87.XM.89.38

Still Life with
Vines and Shadows,
Possibly George-
town Island, Maine

Circa 1920

Platinum print
20.4 × 15.4 cm
87.XM.89.35

Barn Interior,
Probably New England

Before 1931

Platinum print
20.5 × 15.6 cm
84.XP.704.2

Doris Ulmann attended the Ethical Culture School in New York before beginning the study of psychology at Columbia University in 1907. She also took classes in photography with Clarence H. White in the art department at Columbia Teachers College. White, a one-time colleague of Alfred Stieglitz and a founding member of the Photo-Secession, taught photography in the company of the artists Arthur Wesley Dow and Max Weber. Dow, a printmaker who had earlier been an assistant curator of Japanese prints at the Museum of Fine Arts, Boston, promoted the Eastern principles of creating in two dimensions, accenting the abstract, graphic qualities of any composition. That sensibility is evident in *Harbor Scene* (pl. 1).

White founded two schools of his own: one at a summer home on Georgetown Island, Maine, the other in New York. It is believed that Ulmann participated in both. She probably met Dr. Charles Jaeger, an amateur photographer who later became her husband, through White's classes; the two of them were active members of White's Pictorial Photographers of America. These three views may have been obtained during that group's outings from New York or near White's Maine school.

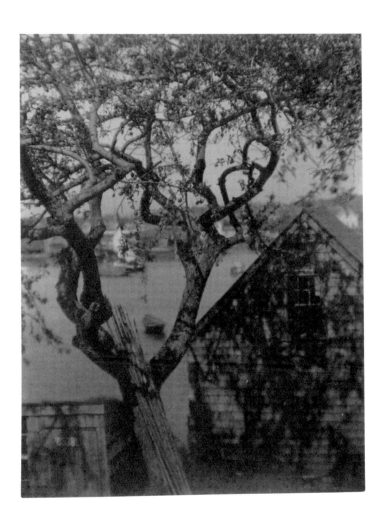

PLATE 4

Two Men at Work

Circa 1916–25

Platinum print
20.6 × 15.5 cm
87.XM.89.152

This picture probably dates from the second
decade of this century, when Ulmann was
experimenting a great deal with the painterly
processes of gum bichromate and bromoil
printing and making numerous studies
of dockworkers, fishermen, and farmers in
New England. The composition, of two
men sharpening mowing equipment, gives
prominence to the tools, using them to
anchor the image and, at the same time,
suggest movement. The foreground arrange-
ment of these functional geometric forms
also provides important balance for the rec-
tangles of subtle shadows in the background.
In the printing of this platinum image,
the figure of the older worker, whose face
is marked by the effects of age, has been
highlighted, while his younger companion
has been made to recede into the deep
grays of the medium.

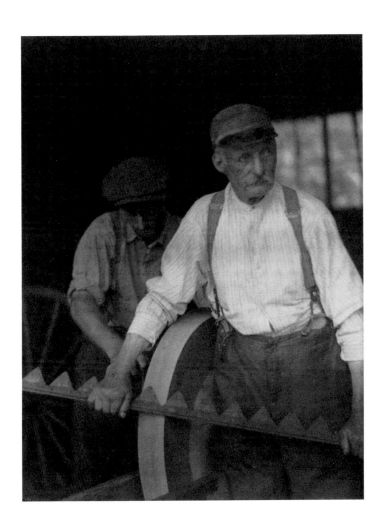

PLATE 5

Cobbler,
West Ninety-Second
Street, New York City
Circa 1917–22

Platinum print
20.9 × 15.7 cm
87.XM.89.112

The laborer shown at work appears to
have been a dominant theme in Ulmann's
photography from the beginning. This com-
position is strikingly similar to images of
tradespeople that the German photogra-
pher August Sander would begin to produce
in the 1920s. Sander's personal archive of
German faces, albeit more systematic than
Ulmann's American series, is comparative
in its technical aspects, nationalistic enthu-
siasm, and obsessive, independent nature.

In a relatively brief session interrupting
this cobbler's day, Ulmann made five six-
by-eight-inch negatives of the same man in
different poses inside his shop. In one, he
is seen surrounded by shelves of shoes;
in another, he is shown in the doorway at
closer range, revealing the real signs, the
accumulated dirt, of work.

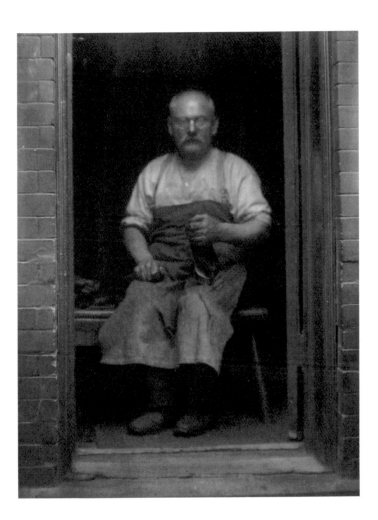

PLATE 6

Construction Worker
on a Cigarette Break
1917

Platinum print
20.6 × 15.5 cm
87.XM.89.142

This image of a black construction worker shows that Ulmann's passionate interest in personality and physiognomy was not restricted to one race. In the 1920s she photographed prominent members of the Harlem Renaissance posing formally in her apartment or on stage in dramas about black culture. Around 1930, after making the acquaintance of South Carolina writer Julia Peterkin, Ulmann began to create hundreds of portraits of African Americans living in Southern cities like New Orleans and Mobile and on plantations and in fishing villages in Peterkin's native state.

The mount for this picture is signed "Doris U. Jaeger" and is dated 1917. Evidence of handwork on the print, mostly to enhance the outlines of the circular forms, suggests that Ulmann was not entirely happy with the results produced by her soft-focus lens. While she continued to use this type of lens, she would employ it less and less to achieve the painterly effects of Pictorialism.

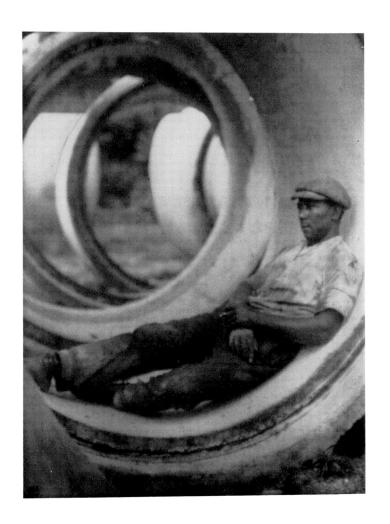

PLATE 7

**Portrait of Max
Broedel, Professor
of Art as Applied
to Medicine, Johns
Hopkins University**
1920

Platinum print
20.7 × 15.7 cm
87.XM.89.99

Ulmann and Jaeger were married early in
the second decade of this century. As he
was a surgeon on the faculty of Columbia
University Medical School, their circle
of friends no doubt included many people
in the medical profession. These associa-
tions and Ulmann's increasing interest
in portraiture probably led her to compile
her first publication, a portfolio of twenty-
four portraits entitled *The Faculty of the
College of Physicians and Surgeons, Colum-
bia University* (1919). This was followed
by a second collection of photogravures,
*A Book of Portraits of the Medical Faculty
of The Johns Hopkins University* (1922). The
latter, appearing under Ulmann's maiden
name, includes an image of the art professor
Max Broedel in a white smock posed next
to one of his drawings depicting a surgeon

in the midst of an operation. The artist holds
drawing pencils as if at work, but directs
his serious gaze at the photographer instead
of his medical subject. In contrast, the Getty
print shows Broedel in a more relaxed pose.
Although Ulmann asserts in the introduc-
tion to her 1922 book that sitters were more
likely to take natural attitudes with "less
tendency to assume an unconscious photo-
graphic expression" if represented in famil-
iar surroundings, this picture was probably
made in her studio. A subtle silk backdrop
replaces the more usual lab or office setting.

PLATE 8

Ruth Page
Performing with Masks
Circa 1920–30

Platinum print
20.6 × 15.6 cm
87.XM.89.24

An upper-class New Yorker whose father was an avid amateur pianist, Ulmann frequently attended theater, music, and dance productions in the city. She occasionally asked individual performers to pose for her; sometimes she would photograph the entire company on stage. Dancers, including Martha Graham, Anna Pavlova, and Ruth St. Denis, were among the artists she admired and chose to portray, usually in costume, but not always assuming a position from a recent composition. Besides these legendary names, Ulmann was also attentive to other important contemporary innovators in modern dance and ballet, like Michio Ito and Ruth Page.

Page, who made her professional debut about 1918 with Pavlova's corps and later formed her own ballet troupe, is identified as the woman behind the mask in this unusually whimsical Ulmann work. It may be that these masks and the apparent Spanish mantilla Page is wearing were part of the dancer's collection of artifacts brought back from many touring engagements. Ulmann also photographed her in costume for the stage piece *Tropic,* however, which Page's biographer describes as "dealing with equatorial decadence." The masks Page is holding seem to be in the same Polynesian vein as the ones Nicolas Remisoff designed for her to wear, with little more than tie-dyed scarves, when she performed that provocative dance.

The vertical streaking on this print resulted from an uneven application of the final wax or varnish coating that Ulmann favored for finishing her platinum work.

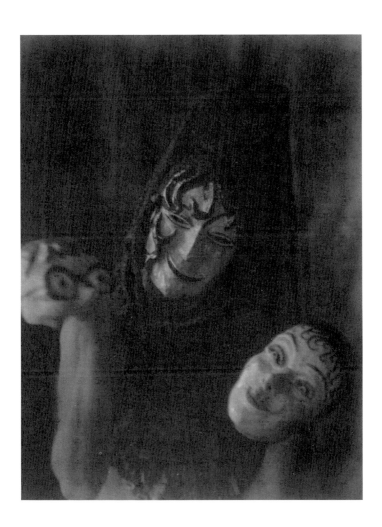

PLATE 9

**Irvin S. Cobb and
Robert H. Davis,
Editors of *Munsey's
Magazine***
1924–25

Platinum print
20.1 × 15.8 cm
87.XM.89.98

In 1925 Ulmann published forty-three
gravure images in a deluxe volume called
A Portrait Gallery of American Editors. She
managed to obtain pictures of two women,
Edna Woolman Chase of *Vogue* and Elizabeth
Brown Cutting of the *North American Review,*
but aside from these two photographs,
the book consists of likenesses of such men
as Frank Crowninshield, Robert H. Davis,
H. L. Mencken, George Jean Nathan, and
Carl Van Doren. The Getty's double portrait
was not chosen as one of the book's plates;
a more revealing close-up of Davis (right)
was published instead. Ulmann's preface
gives these editors of contemporary journals
a great deal of credit for forming popular
opinion, even creating the current "perception
of humour," but Davis's own commentary
on his profession ends with a less elevated
view: "Probably when the world's great-
est editor is discovered it will be revealed
that he thinks *like* the people instead of
for them."

PLATE 10

José Clemente Orozco

Circa 1929

Platinum print
20.2 × 15.4 cm
87.XM.89.97

José Clemente Orozco, the Mexican painter and muralist, worked in the United States between 1927 and 1934, creating murals in New York, California, and New Hampshire. His work was promoted by Alma Reed, who established the Delphic Studios in New York and in 1929 gave Ulmann her first solo exhibition. Orozco would have a show in Reed's gallery the next year; in 1929 he was exhibiting at the Downtown Gallery and the Art Students League. The populist intent of his murals no doubt drew Ulmann to this intense artist, who she probably met through Reed or other art world connections. Whatever the attraction, the two became close enough that the photographer not only made several portraits of him but also gave a cocktail party at her apartment for his forty-sixth birthday.

Orozco may have sat for her camera at about this time, posing in his studio or at a gallery before what appears to be one of his own paintings or mural studies. While in the United States, he would also sit for the photographers Edward Weston and Ansel Adams. In those portraits the painter stares determinedly into the distance from behind the thick round glasses he normally wore. Ulmann pictures him without his glasses, capturing his penetrating gaze.

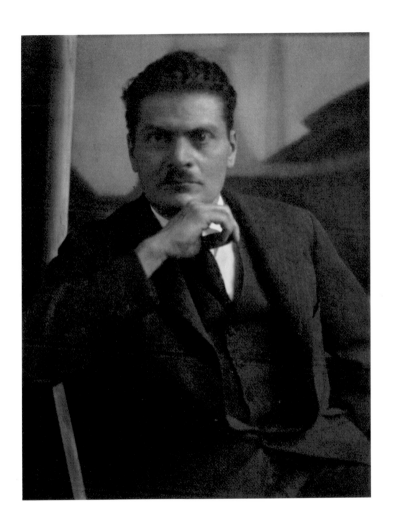

PLATE II

**Brother William
of the Shaker
Settlement, Mount
Lebanon, New York**
Circa 1925–27

Platinum print
20.5 × 15.3 cm
87.XM.89.106

In the mid-1920s Ulmann began in earnest what would be a lifelong project—photographing American "types." Her first trips out of New York City for this purpose resulted in portraits of Dunkards, Shakers, and Mennonites living in rural parts of Virginia, New York, and Pennsylvania.

Elder William Anderson, who would die at the age of eighty-nine in 1930, was a prominent member of the much-diminished Shaker sect residing at the site of the original eighteenth-century settlement near New Lebanon, New York. According to an article published in a local paper on the occasion of his eighty-fifth birthday, Anderson was raised in New York City but came to the Mount Lebanon colony seeking "new adventures." His responsibilities there eventually included teaching, farming, surveying, book-keeping, and, for forty years, overseeing the chairmaking business of the colony. The *Biographical Review*'s 1894 volume on *The Leading Citizens of Columbia County* listed him as one of five males making up the "twenty souls" of the colony's South Family and described him as someone with "much executive ability" who was well respected by his employees, "a great many of whom are hired from outside the village, most of the men here being very aged."

When Ulmann photographed him around 1927, Anderson was deaf and almost blind, but he still possessed, at least through her lens, the same dignity and commanding presence that had made him a leader of those trying to survive outside mainstream American society.

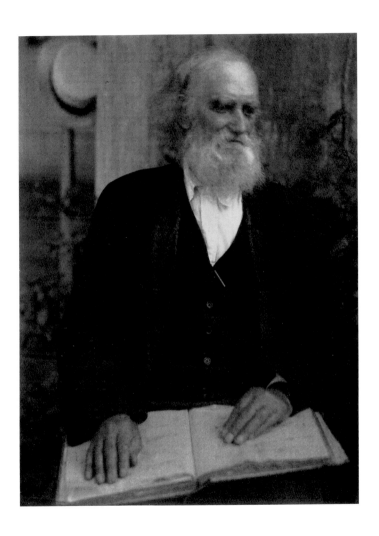

PLATE 12

**Sister Sarah
of the Shaker
Settlement, Mount
Lebanon, New York**
Circa 1925–27

Platinum print
20.3 × 15.5 cm
87.XM.89.63

Sarah Collins was an eldress at the Shaker
colony of Mount Lebanon. She is shown here
holding some needlepoint, possibly from
the shop she ran that featured crafts pro-
duced by the sect. When Ulmann visited
her, this longtime head of the Shaker's
South Family society was in her early sev-
enties. Like many of her faith, she would
live to an unusually old age, dying at ninety-
two. The Shakers' individual longevity,
and their imminent disappearance in spite
of it, most likely attracted Ulmann to this
small but industrious group.

A few years after Ulmann photographed
Collins, the eldress would, at the time
of Elder Anderson's death (pl. 11), bring his
additional talent for draftsmanship to the
attention of the local press and make a
donation of one of his drawings to the local
art museum.

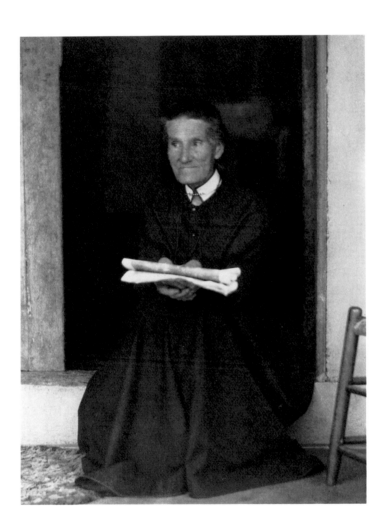

PLATE 13

The Minister's Wife, Ephrata, Pennsylvania

Circa 1925–27

Platinum print
20.3 × 15.6 cm
87.XM.89.64

PLATE 14

The Minister at Ephrata, Pennsylvania

Circa 1925–27

Platinum print
20.1 × 15.4 cm
87.XM.89.140

Ulmann recorded this couple individually and together in a series of fifteen poses. These austere pictures are reminiscent of pendant portraits by fifteenth-century Netherlandish artists like Jan van Eyck or Rogier van der Weyden. The minister, probably the head of a Dunkard congregation, was featured in "Character Portraits by Doris Ulmann," a 1927 article authored by Hamlin Garland, a pioneer of the new naturalism in American literature. Nine of what Garland called Ulmann's "sympathetic records of American types" appeared in this *Mentor* piece, which described the minister as "well-read" and having "a keen mind" but being very skeptical of a stranger's interest in taking his picture. Ulmann was apparently convincing, because "when he realized that the photograph was not to be used for exploitation purposes he gave his consent in a charming manner." She then arranged him before three different backgrounds and directed him in a variety of poses, usually involving the small Bible he is shown holding in this plate. His wife seemed to hold less interest for the photographer. The stern woman is presented here in a print that sets off her face and delicate, customary white cap against a broad swath of blackness.

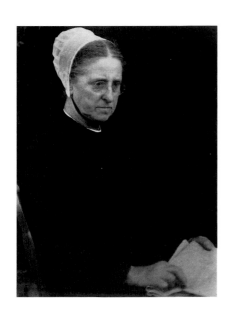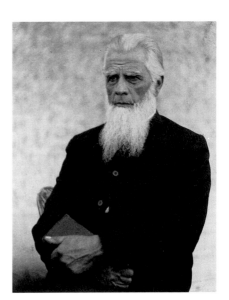

PLATE 15

John Jacob Niles
Playing the Dulcimer,
New York City

Circa 1930

Platinum print
20.1 × 15.3 cm
87.XM.89.7

Ulmann and Jaeger had divorced by the mid-1920s. In 1925 she met John Jacob ("Jack") Niles, an actor, musician, and Kentucky balladeer. By 1927 he had become her general assistant as well as frequent escort on evenings out at the theater, opera, and ballet. As a Park Avenue resident of independent means, Ulmann had a staff to maintain her apartment and provide transportation when needed. However, a knee injury made it difficult for her to carry the heavy photographic equipment (glass plates, view cameras, and tripods) with which she preferred to work. Niles was hired not only to assist with the equipment but also because he could facilitate Ulmann's introduction to more remote parts of the mountainous Southeast, where she would

increasingly spend more time. As one who shared her interest in preserving the culture of the Southern Highlands, he acted as an informed assistant and helpful collaborator.

The two were on the road as much as five clement months each year; during the winter months Niles was often away on concert tours with his partner, the singer Marion Kerby. He sometimes stayed with Ulmann when in New York and, under her close supervision, assisted with the printing process. Her involvement with his life extended to making sure he had a sufficiently stylish wardrobe. This portrait and the one seen on page 115 picture Niles with the tools of his primary trade, that of collecting, composing, and performing folk music.

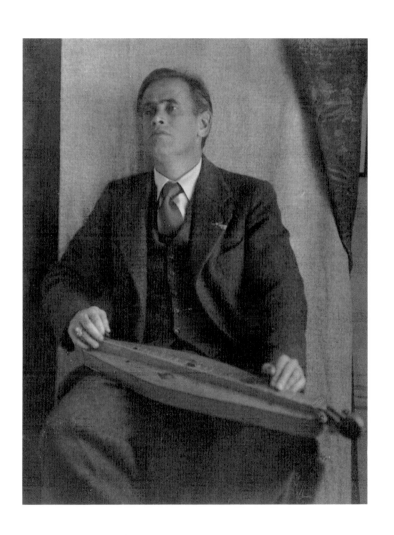

PLATE 16

**John Jacob Niles
in Hat and Overcoat**

Circa 1927–34

Platinum print
20.2 × 15.4 cm
87.XM.89.19

Niles has been described by scholars and acquaintances as a chameleon. Ten years younger than Ulmann, he was born in Louisville, Kentucky, in 1892 and grew up on a farm in Jefferson County. His father, a man of many professions, brought folk music of all types into his family's home; Niles began collecting regional ballads as a teenager. By contrast, he also studied music at the Université Lyon and the Schola Cantorum in Paris, read poetry for Gertrude Stein's salon, prepared for a career in opera at the Cincinnati Conservatory, and was performing in the New York theater when Ulmann met him in 1925. From the 1920s on he would publish more than fourteen collections of music and give salon and stage concerts around the world.

Niles was a natural entertainer and raconteur who was as comfortable in formal wear at the ballet as in overalls on a Kentucky farm. Ulmann's playful study of him seems an apt expression of his versatile character and of the mutual attraction that sustained their collaborative work.

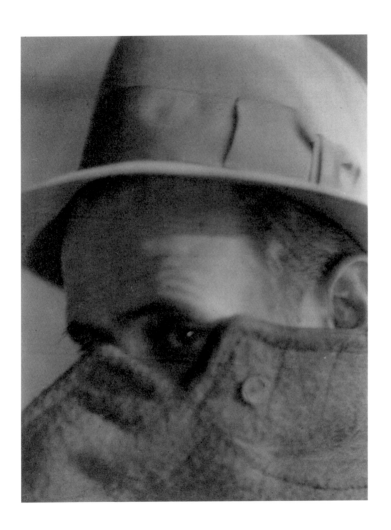

PLATE 17

A Study of Hands
(John Jacob Niles
Unlocking the Door)

Circa 1932–34

Gelatin silver print
20.4 × 15.2 cm
87.XM.89.20

The posthumous proof-print albums housed at the University of Oregon contain a dozen or so pictures of Niles's hands that are part of a private, whimsical, seemingly affectionate series that the two collaborators probably carried out in Ulmann's New York apartment. Among the work of her contemporaries, August Sander's studies of craftsmen's hands and Lotte Jacobi's compositions concentrating on the hands of her sometimes illustrious sitters might be noted for comparison, but Alfred Stieglitz's images of Georgia O'Keeffe's hands posed on the chrome rim of her new automobile or over her bare breasts have more in common with these personal pictures by Ulmann. The erotic tone of Stieglitz's photographs of his lover can also be found in this study; it has been suggested that the forceful, grasping pose of Niles's left hand and the forward gesture of his right hand as he inserts the key into the lock are both heavily laden with intimations of sexuality.

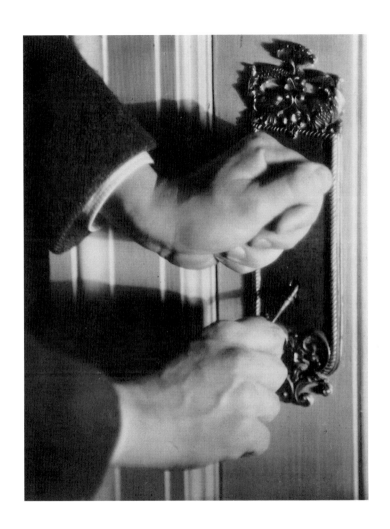

PLATE 18

Sidewalk Grocer,
Bleecker Street,
New York

Circa 1925–30

Platinum print
20.1 × 15.3 cm
87.XM.89.114

This grocer in New York's Greenwich
Village most likely became Ulmann's sub-
ject through an introduction by Niles.
She did not habitually photograph people
on the street, either in New York or in
the Southern communities she visited, so
this image, part of a rare series of vegetable
sellers and other sidewalk vendors, may
have been done at Niles's suggestion. Each
of at least ten New York merchants repre-
sented in the albums at the University of
Oregon struck several poses for Ulmann,
usually looking away from the camera.
This man appears to have been the most
comfortable, perhaps because he was
better acquainted with Niles. In fact, he
may have been a subject for the musician
as well as for the photographer. Niles,
at one point an aspiring opera singer, was
at the time composing a musical drama
called *The King of Little Italy.*

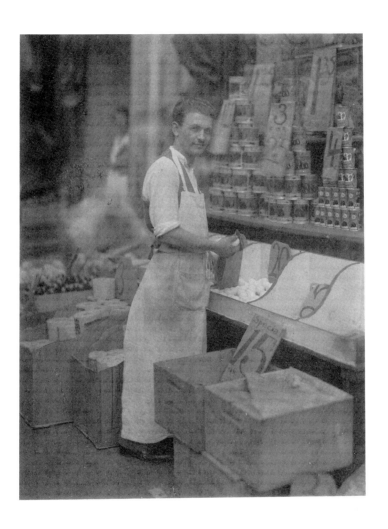

PLATE 19

Bill Williams's Boy, Whitesburg, Kentucky

Circa 1928–34

Platinum print
20 × 15.4 cm
87.XM.89.47

This portrait may have been produced on Ulmann's first trip to the South with Niles in 1928. They visited the Hindman Settlement School and met with folk musicians while in Kentucky; this boy might have been the son of one of their hosts in Whitesburg. His pose, like that of the young black girl seen in *Portrait Study* (pl. 23), has clearly been assumed under careful direction from the photographer. The introspection the picture expresses seems quite modern, but the dark tonality and soft-focus rendering cause it to take on the melancholy mood of turn-of-the-century Pictorialism. The influence of Clarence White, Ulmann's friend and teacher, is suggested by the subject of the child (White often used his own children as models) and in the atmosphere of reverie similar to White's own vein of Romanticism. The black void at the left, which, along with the window frame, is part of Ulmann's framing device, implies physical as well as spiritual isolation, a condition she may have sensed or projected upon this small-town resident.

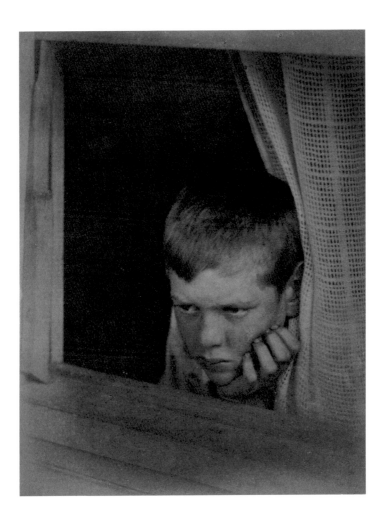

PLATE 20

**Young Wife,
Possibly
North Carolina**
Circa 1928

Platinum print
20.1 × 14.9 cm
87.XM.89.76

In 1928, the year a federally funded American Folklife Center was initiated, the August issue of the *Mentor* featured numerous articles about the Appalachian Trail and life in the Southern Highlands, including "Old-Time American Stock" (introduced by one of Ulmann's pictures), "Martha Berry and Her Mountain School," and "Elizabethan Settlements in North Carolina."Additionally, Ulmann's "Among the Southern Mountaineers," a portfolio of sixteen portraits, had a prominent place in this edition of the journal. The captions designate the sitters as an eighty-three-year-old man who "had never been photographed," a "splendid type of young American manhood" displaying the "fearlessness and sturdiness of the mountains," a former miner whose relatives were "among the first settlers," and this young woman, shown in a more sympathetic pose that situates her in a garden setting,

described as a "daughter who said that the hardest thing, when married, was to leave her mother." A broad-shouldered, unpampered woman apparently used to farm labor, she is also quoted as saying that she thought "it easier to work in a cornfield than to pose for a picture." She appears to be of mixed race, like the woman at her laundry in *Monday* (pl. 21), and is possibly a descendant of what is sometimes referred to as the "lost tribe of Raleigh." Although not representative of the pure Anglo-Saxon strain thought to be isolated in the Southern Highlands, this individual embodies another contemporary fascination of East Coast intellectuals. Such books as Carl Van Vechten's *Nigger Heaven* (1926) and Julia Peterkin's *Bright Skin* (1932, dedicated to Ulmann) had as their subject the paradoxical life of persons of mixed blood.

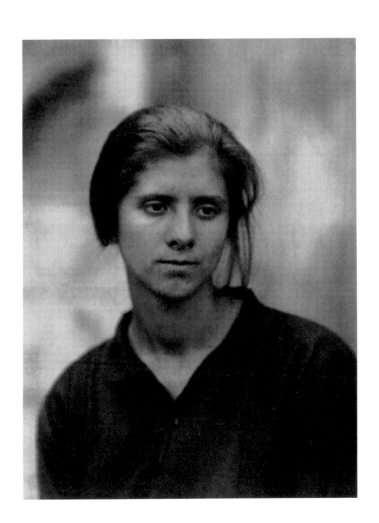

PLATE 21

**Monday
(Melungeon Woman,
Probably
North Carolina)**
Before 1929

Platinum print
20.1 × 15.4 cm
87.XM.89.73

As a portraitist, Ulmann was always striv-
ing to capture with her camera "a face that
has the marks of having lived intensely."
The strong features of this hard-working
Melungeon woman obviously appealed to
her. The difficult life endured by the women
of this venerable group of Americans—
descendants of mixed marriages between
early settlers and Native Americans (in this
case probably the original Cherokee inhab-
itants of Tennessee and the Carolinas)—
is illustrated by the primitive washing equip-
ment and echoed in the twisted tree trunk.
The image loss at the upper left, which per-
haps occurred during a hot summer's drive
back to New York, unintentionally reinforces
the anxious look of deprivation displayed
by this long-isolated young woman. Sur-
prisingly, the print was published with
this conspicuous flaw in the 1929 issue of
Pictorial Photography in America.

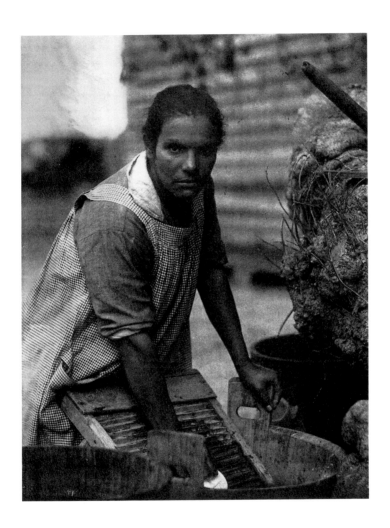

PLATE 22

Cherokee Woman,
North Carolina

Circa 1929

Platinum print
20.3 × 15.2 cm
94.XM.101

The provenance of this photograph suggests that it may have been part of Ulmann's show at Alma Reed's Delphic Studios in 1929. An article in the February 1930 issue of *Theatre Arts Monthly*, essentially a review of the show, is illustrated with eight photographs, including a portrait of an elderly Catawba Indian. The *Theatre Arts* critic praises Ulmann's work as a reminder of "the richness and depth and variety of dramatic treasure to be found in the mountains and valleys of country districts."

Ulmann worked with the Catawba tribe at their community near Rock Hill, South Carolina, and with the Cherokees on a reservation in western North Carolina, perhaps in the company of Peterkin, years before making pictures for Allen Eaton's *Handicrafts of the Southern Highlands*

(1937). Like Eaton, Ulmann was also interested in the craft traditions of these Native Americans. In what would seem to be a straightforward ethnographic record of this tribe's simple gray pottery, she skillfully gives as much attention to the individual as to the artifact. In *Handicrafts,* Eaton explains the craft process, relating that the Cherokees would gather clay from their reservation, shape it into forms by hand, and then "dry them in sun and wind, and harden them in the ovens and fireboxes of their cookstoves, where the gray clay is often smoked brown or burnt black from contact with blazing wood."

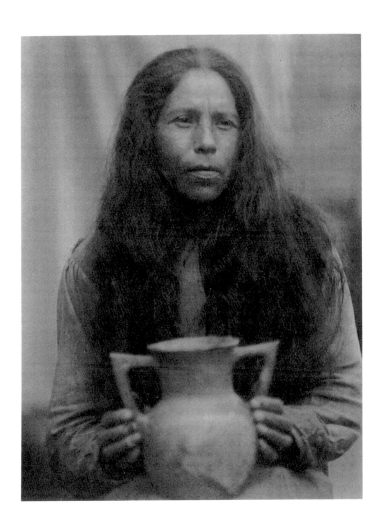

PLATE 23

**Portrait Study,
Probably
South Carolina
or Louisiana**
Circa 1929–31

Platinum print
20.6 × 15.4 cm
87.XM.89.81

In 1929 Peterkin's novel *Scarlet Sister Mary* (1928), a depiction of twentieth-century plantation life, won the Pulitzer Prize. About the same time, she began collaborating with Ulmann on a book that was initially to be built around photographs of African American life and customs in areas of the South designated by Peterkin, such as New Orleans, Mobile, and South Carolina. It appears that changes in their relationship caused this work, entitled *Roll, Jordan, Roll* (1933), to evolve into a collection of Peterkin's writings with scattered illustrations by Ulmann. It is still unclear who selected and sequenced the pictures. Although this study of an adolescent girl was not used in the volume, it seems to represent much of what is said in Peterkin's chapter on the subject of children. She describes this critical time in a child's life: "Twelve is the age of responsibility, when the recording angel in heaven writes a child's name in a book and marks down every sin against it. . . . Under twelve a child is a 'young child,' and if he dies his soul will not fail to reach heaven, but twelve is the deadline age that changes a 'young child' to an 'old child.'"

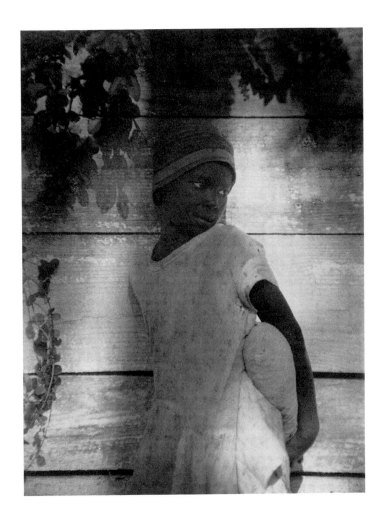

PLATE 24

Maum Duck,
South Carolina

Circa 1929–31

Platinum print
20.6 × 15.6 cm
87.XM.89.51

This woman, who appears to be dressed for church, has been variously identified as a midwife and a voodoo doctor. A smiling, even more frontal portrait of her is used as an illustration in a chapter of *Roll, Jordan, Roll* that contains a detailed listing of superstitions and incantations Peterkin thought were still practiced by the African American population of Lang Syne, her South Carolina plantation. Just as Niles collected centuries-old Southern folk songs, Peterkin gathered the ancient beliefs of medicine and magic that surrounded her. In the text that Maum Duck illustrates, conjuring is described as follows: "'Good' conjurers deal in white magic and make charms to cure sickness and heartaches. . . . Reliable love charms are made with a strand of hair, a bit of skin from a heel, a tiny paring of toe nail or finger nail, and no living man can resist the love-spell cast upon him if the lady who wants him will wear a bit of his shirt tail tied to a string around her waist."

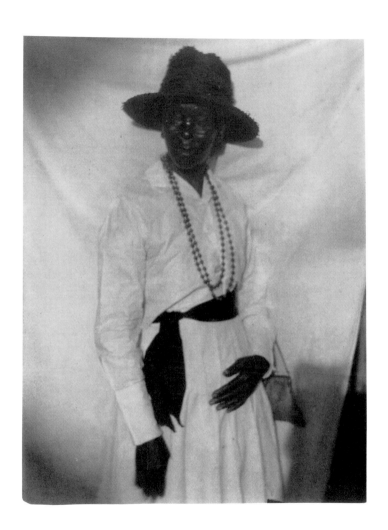

PLATE 25

The Grave of Hackless Jenkins, Probably South Carolina

Circa 1929–31

Platinum print
15 × 19 cm
87.XM.89.25

This image is one of three pictures in *Roll, Jordan, Roll* illustrating a discussion of the Bury League, a cooperative society established to provide respectable funerals for its members. Peterkin relates the story of an elderly woman who, to the relief of her neighbors, volunteered to be the first buried in a new graveyard. She made this brave decision in the face of a superstition that said, "the first person buried in a graveyard never rests easy." Although she had not joined the Bury League or accepted other "changes that crept into the plantation" (supposedly Peterkin's Lang Syne), the League brought out the hearse for her funeral and made it a grand celebration. "When the low mound of earth was smoothed and the Bury League white paper flowers laid on it, things she prized on earth were put with them: a clock that had not ticked for many years, the cup and saucer she used, a glass lamp filled with kerosene, and a china vase holding fresh blossoms from those growing around her doorstep." Walker Evans, who would visit Lang Syne in the mid-1930s, was also fascinated with the household objects that decorated otherwise simple Southern graves. He photographed them later in Alabama, and his collaborator, James Agee, would depend upon these images as he wrote *Let Us Now Praise Famous Men* (1941).

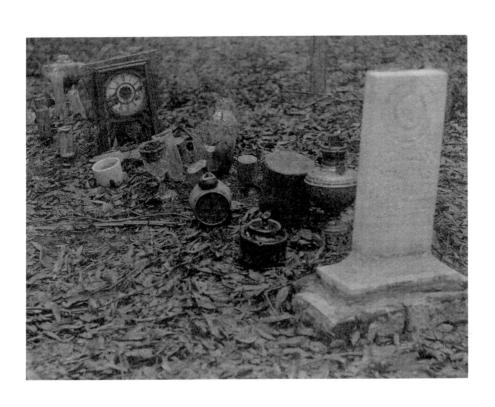

PLATE 26

**Portrait of Miss Katy,
South Carolina**

Circa 1929–31

Platinum print
20.6 × 15.5 cm
87.XM.89.66

Ulmann photographed Miss Katy for
Roll, Jordan, Roll. The text adjacent to the
portrait, a first-person account delivered,
as in much of the book, in dialect, tells
of the pain in Miss Katy's life caused by the
working of roots (a conjuring) and of the
consolation that the pipe and praying have
brought her. Both Peterkin and Ulmann
were concerned with this woman as an
individual, not just as the timeworn type of
peasant portrayed by English and French
Realist painters of the nineteenth century.
She is, actually, one of the few people pic-
tured in *Roll, Jordan, Roll* who can be fully
identified. According to Susan Williams,
Peterkin's biographer, Miss Katy Jones had
been the subject of an earlier Peterkin
sketch called "Roots Work," which became
a kind of starting point for a cycle of short
stories published in 1924 as *Green Thursday.*
Jones died in 1932 at the age of sixty-five,
one year before the publication of *Roll,
Jordan, Roll.*

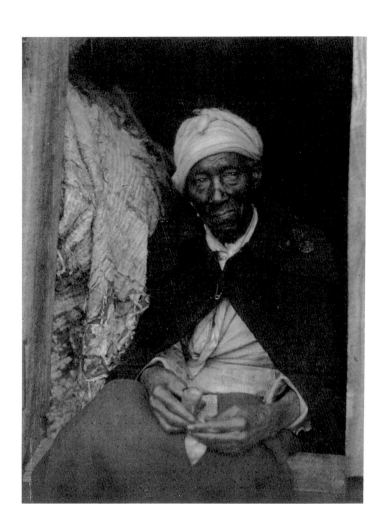

PLATE 27

The Herbalist,
Probably Louisiana
or South Carolina
Circa 1929–31

Platinum print
20.1 × 15.1 cm
87.XM.89.84

This woman appears to be not only of an-
drogynous character but also of mixed race.
The mystery of her origins and sexuality
seems appropriate for one who practiced
curing and conjuring with the help of
herbal recipes. Ulmann may have created
this portrait for *Roll, Jordan, Roll;* the her-
balist was a powerful figure in the black
quarter of Lang Syne. Although her glance
seems to indicate that she has been en-
countered while casually tending plants
on her porch, this subject was arranged
by Ulmann in at least six other poses, some-
times accompanied by a young black boy,
usually in more dilapidated surroundings.

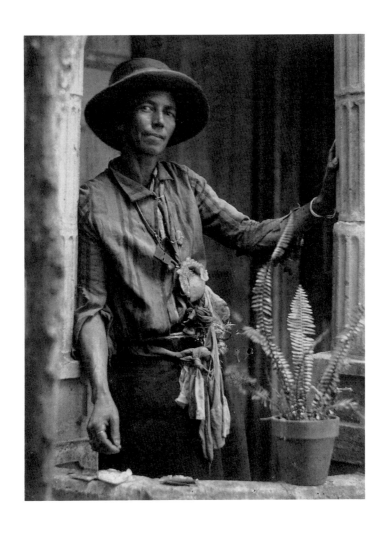

PLATE 28

Member of the Order of Sisters of the Holy Family, New Orleans

December 1931

Platinum print
21.3 × 16.3 cm
87.XM.89.80

At the urging of Peterkin, Ulmann made several trips to New Orleans between 1929 and 1931. There she became intrigued with the Creole and Cajun residents as well as with the Sisters of the Holy Family convent in the city's French Quarter. She photographed the nuns (most of them African American) individually, in groups, and with their black students. This unidentified portrait presents a sister who seems to possess a regal bearing, her hands carefully cradling spectacles, and reflects Ulmann's interest in cloistered or isolated communities.

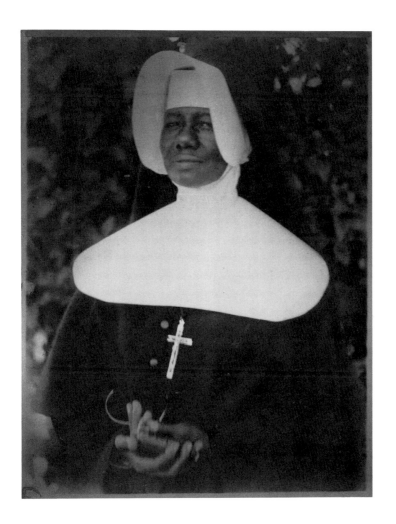

PLATE 29

**Fisherman with
Wooden Leg,
Near Brookgreen
Plantation,
Murrells Inlet,
South Carolina**
Circa 1929–31

Platinum print
19.9 × 15.1 cm
84.XP.704.6

For a brief time in the early 1920s Peterkin's family owned Brookgreen Plantation on the South Carolina coast near Murrells Inlet. The writer would spend her summers at the inlet, making creative use of the setting while working in a small cottage. On at least one occasion Ulmann traveled from New York to Myrtle Beach; from there the two artists went out in search of photographic material for *Roll, Jordan, Roll.* As she had when she first began photographing, Ulmann sought out the working men of the area. The fishermen of the coastal communities were apparently a favorite subject. She exposed at least twelve plates of this handicapped young man and made more than twenty negatives of a man and boy (p. 125). Ulmann probably directed the poses—the position of this lone fisherman is remarkable in its quiet grace and its reference to the carefully balanced contrapposto of the Apollo Belvedere. Peterkin, the novelist, may have been more interested in fiction than the familiar, but she nevertheless promoted Ulmann's quest for the authentic, especially when it involved picturing black life.

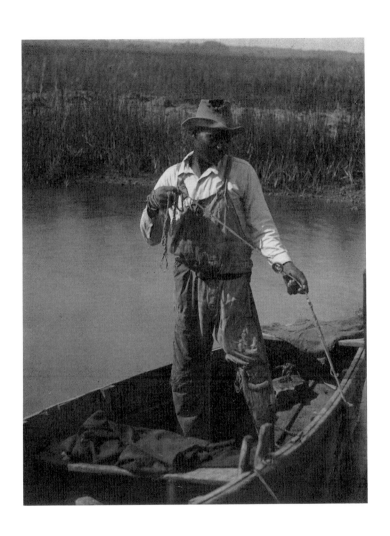

PLATE 30

**Father and Son
with Harvested
Berries,
Possibly Kentucky**
Before 1931

Platinum print
20.4 × 15.5 cm
84.XP.704.4

While less severe in its connotations of poverty and paternal discipline than Ulmann's image of a Georgia farmer with his daughters that Edward Steichen would select for his 1955 *Family of Man* exhibition, this portrait of a father and son is similar in its emphasis on the strong family bonds born of the necessity of work and the isolation of rural living. A second son, who for the most part is eliminated from this tightly cropped composition, is represented only by a small hand, seen grasping the pot of berries at left. The young father, a hard-working, seemingly self-sufficient type, symbolizes the tall, thin Anglo-Saxon mountaineer who would be idealized in American Scene painting and nationalistic literature during the period between the world wars. The theme of the legacy of generations, in terms of crafts and values as well as property and physical features, is also reflected in this image.

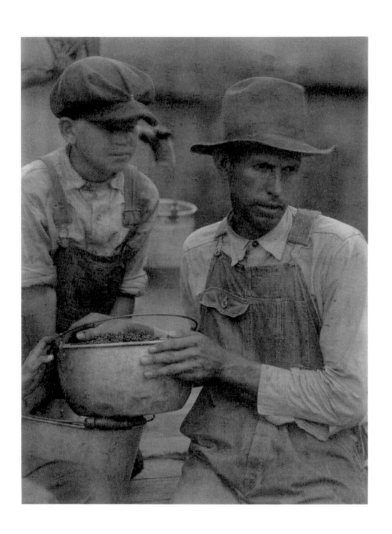

PLATE 31

Farm Couple with Picked Cotton, Southeastern U.S.

Before 1931

Platinum print
20.1 × 15.2 cm
87.XM.89.155

In her nearly twenty years of serious photographic activity, Ulmann portrayed many couples, both famous and obscure. The prominence of these individuals seemed to matter less than their respective talents and the relationship captured by the camera. This anonymous double portrait is found in the midst of images of Native Americans and African Americans in an album at the University of Oregon that also contains two other views of this man and woman with four children, apparently the rest of their family. Ulmann chose to print in platinum this image of the couple alone, thereby simplifying both the composition and the personal dynamics involved. The two are not shown in the process of harvesting the cotton crop, but are displaying it, in a more decorative than documentary manner. The husband, kneeling in shadow, serves only as a complementary prop for his wife, who is presented in a light-colored dress and bonnet, the latter possibly donned just for this photograph. Ulmann's rendering of this rural pair appears at first to be more formally posed than those made a few years later by federally sponsored field photographers like Walker Evans and Dorothea Lange, but it is, in fact, no more staged than many of their pictures, obtained in the cause of social reform.

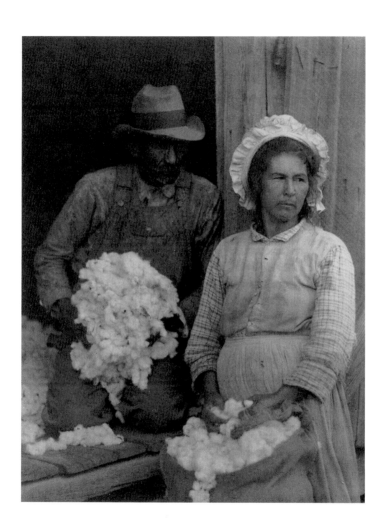

PLATE 32

Aunt Cord Ritchie
and Family,
Hindman, Kentucky
Circa 1932–34

Platinum print
20 × 15.3 cm
87.XM.89.150

In 1971 Niles provided an introduction for the first monograph to be published about Ulmann's work, *The Appalachian Photographs of Doris Ulmann.* According to his recollections in that book: "They seemed to be waiting for her, the old women at the spinning wheels, the younger women sitting at the loom, and the children carding wool.... These were the people she really wanted to get down on paper for posterity. She thought they would finally disappear."

Made in preparation for Allen Eaton's *Handicrafts of the Southern Highlands,* Ulmann's portrait of Aunt Cord Ritchie and her descendants presents three generations of basket weavers. Ritchie, a self-taught craftswoman who "made up" both the dyes and classic shapes she used for her Highland baskets, preferred working with willow, although she also employed oak and hickory splints. Once married to Uncle Solomon Everidge, a founder of the Hindman Settlement School, she was said to have instructed all the weavers of willow baskets then active in Knott County.

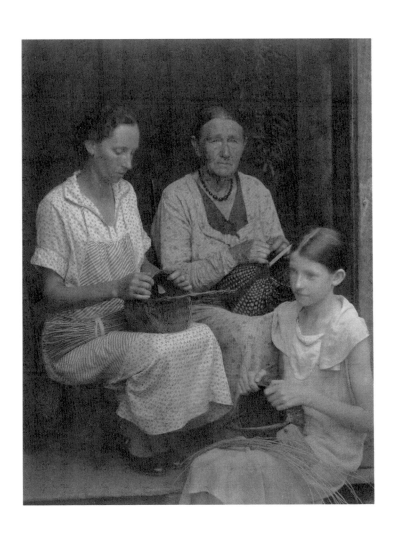

PLATE 33

Grace Combs,
Hindman, Kentucky

Circa 1928–34

Platinum print
20.2 × 14.9 cm
87.XM.89.78

"They all want to go and dress up," Ulmann
said of the subjects she preferred to pho-
tograph in their day-to-day clothing and
habitat. Grace Combs appears to be one of
those sitters who wanted to be shown
in stylish pose and costume, but she may
also have been one of a number of Hindman
Settlement School students Ulmann chose
to portray for their youthful attractiveness
and desire to be as current as their meager
resources would allow. The University
of Oregon proof-print albums reveal that at
this session Ulmann made quite a few pic-
tures of Combs, with and without her gloves
and hat, seated, and in close up, all captur-
ing her naturally seductive gaze. Combs
was no doubt related to the first graduate of
Hindman, Josiah H. Combs, who, in the
mid-1920s, completed a dissertation for the
Sorbonne on folk songs of the middle
United States.

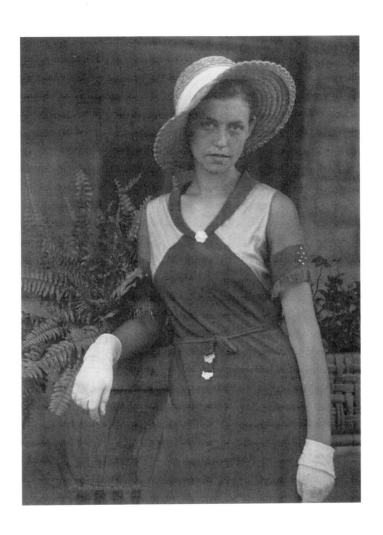

PLATE 34

Interior of Olive Dame Campbell's House, Brasstown, North Carolina

Circa 1933–34

Gelatin silver print
20.3 × 15.2 cm
87.XM.89.29

In the last two years of her life, Ulmann became well acquainted with Olive Dame Campbell, an industrious New Englander who had traveled many miles in the Appalachian Mountains while surveying the culture with her husband for the Russell Sage Foundation. Campbell put part of her energy into collecting ballads in the Southern Highlands and later, after her husband's death, opened a school (based on a Scandinavian model for rural education) in Cherokee County, North Carolina. She would direct the John C. Campbell Folk School for twenty years, following a tradition already well established by such women as May Stone of the Hindman Settlement School and Katherine Pettit of the Pine Mountain School. Ulmann also photographed

at these two manual arts centers in Kentucky, but she used Campbell's school at Brasstown as her base of operations several times while creating illustrations for *Handicrafts of the Southern Highlands,* published by the Russell Sage Foundation after her death.

This interior may have been intended for the book, since it displays, as do included images, a variety of handmade articles, most of them probably created by students or local craftspeople. The clean lines and natural surfaces of Campbell's home no doubt reflected her own taste as much as that of her neighbors. The style is the antithesis of the overstuffed clutter of Victoriana that still persisted in Ulmann's New York. This composition reveals her admiration for Campbell's modest, dedicated lifestyle.

PLATE 35

**Christopher Lewis,
Preacher,
Wooton, Kentucky**
Circa 1928–34

Gelatin silver print
20.3 × 15.2 cm
87.XM.89.121

Wooton Fireside Industries, established to
promote such mountain crafts as furniture
making, woodcarving, and weaving, was
begun in the 1920s, about the time the John
C. Campbell Folk School was founded near
Brasstown, North Carolina. Eaton, who
was attempting to document the history of
the handicraft revival as well as to describe
in detail these regional practices, may have
sent Ulmann to Wooton to record the crafts-
people gathered there. Preacher Lewis,
however, clearly captured Ulmann's atten-
tion as an important character in the com-
munity. She photographed him in a large,
elaborate handmade chair with and without
his jacket, eyeglasses, and wife. In this pic-
ture the preacher is shown alone clutching
his Bible to his chest, appearing somewhat
anxious but also spiritual.

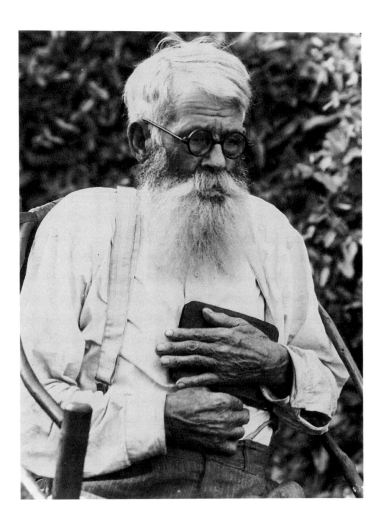

PLATE 36

Jason Reed,
North Georgia
Chairmaker
Circa 1933–34

Platinum print
20 × 15.4 cm
87.XM.89.120

In *Handicrafts of the Southern Highlands*
Eaton states that "chairmaking is rarely
a full-time job, most who carry it on being
farmers who fill in between the seasons
of outdoor work." Reed is probably one of
the craftsmen-farmers Eaton sent Ulmann
and Niles to photograph. She exposed some
fourteen negatives of Reed, recording him
at work making furniture with his simple
wooden tools, enjoying his grandchildren,
and, here, resting with his cane, perhaps
seated on a product of his own handiwork.
Ulmann seems to have been as fascinated
by the aging forms of her subjects as by
their faces; her own partial lameness after a
1926 accident no doubt encouraged this
empathy with the handicapped and infirm.

It also increased the necessity of a strong
assistant like Niles, who, coincidentally, had
a slight limp himself due to wounds suffered
in World War I.

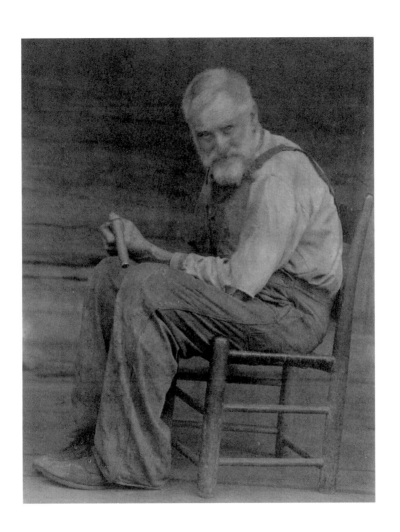

PLATE 37

**Hayden Hensley,
Woodcarver,
Brasstown,
North Carolina**
Circa 1933–34

Platinum print
20.2 × 15.4 cm
87.XM.89.127

Hayden Hensley, one of the first students at the John C. Campbell Folk School, was also its most talented woodcarver. Having grown up on a farm in the area, he attended the settlement school for three years, married a local girl who was working there (also photographed by Ulmann with their child), and built a home nearby (which he paid off with the proceeds of his carving). In *Handicrafts of the Southern Highlands* Eaton used another of Ulmann's portraits of Hensley, captioning it *A North Carolina Mountain Whittler.* Eaton criticized other historians of carpentry for not mentioning the modest pocketknife and the art of whittling.

Among many crafts, woodcarving was encouraged by Campbell at her school, where fruit wood was typically employed, along with holly and maple. For finishing, the whittled pieces were not painted or stained, but were waxed and rubbed. According to Eaton's assessment, the style of the students' carvings was "usually naturalistic, but occasionally . . . a bit futuristic."

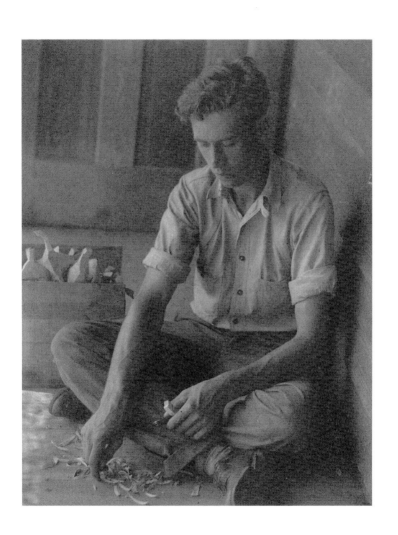

PLATE 38

Landscape with
Pump and Barn
Circa 1920–34

Platinum print
20.8 × 15.6 cm
84.XP.704.3

Although Ulmann spent most of her time
photographing people, she also made some
of the finest Pictorialist landscapes known,
rare examples of which can be found in
the collection of the New-York Historical
Society. She continued to address this sub-
ject with a more Modernist interpretation
during her travels in the South. This
composition lies somewhere between land-
scape and still life, Romanticism and Con-
structivism. It contains elements of material
culture—an old pump, battered metal
tankards, tin roof, and whitewashed fence—
and fragments of natural forms—a fertile
valley, forested hills, and overcast sky. With
the simple lines of vernacular architecture
and ordinary implements, Ulmann has
constructed a sophisticated collage that
is a challenge to contemporary work in pla-
tinum by Paul Strand and Alfred Stieglitz.

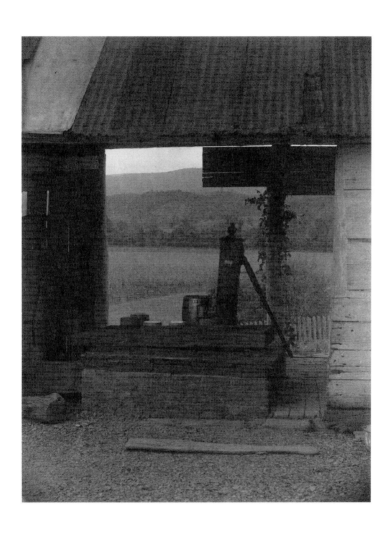

PLATE 39

PLATE 40

**John Jacob Niles
with Lysette Engel
at the Piano,
New York City**

Circa 1926–30

Platinum print
20.5 × 15 cm
87.XM.89.1

**John Jacob Niles
with Carol Deschamps
and a Dulcimer,
Brasstown,
North Carolina**

Circa 1933–34

Gelatin silver print
20.2 × 15.5 cm
87.XM.89.11

As this pair of pictures makes clear, Ulmann lived and worked in two very different worlds: the urban milieu of Manhattan, and the scattered mountain communities of the rural Southeast. Additionally, the pictures emphasize Niles's role in her experience of both worlds.

Niles reportedly was introduced to Ulmann by Carl Engel, head of G. Schirmer, Inc., a music publishing company. Several of Niles's collections were issued by the business, including his *Seven Kentucky Mountain Songs* of 1928. Engel was apparently a family friend of Ulmann's; this portrait of his daughter accompanying Niles on the piano was probably made in Ulmann's apartment. Lysette assumes the appearance of a pensive young woman in this view, compared to the persona of a more awkward

adolescent girl that she displays in the seven additional solo portraits Ulmann made of her on the same day. The company of Niles, in evening dress, seems to impart a new sophistication to her and an air of intimacy to an otherwise innocent double portrait.

Carol Deschamps, who is also placed in close proximity to Niles, was, like Lysette, a teenager when Ulmann took her picture. The photographer made numerous other studies of her in a variety of long, traditional dresses posed with wildflowers or handicrafts. Niles is shown holding a dulcimer, an indigenous instrument he not only played but also made. A romance between the two sitters is inferred; Ulmann's romance with photographing Niles is obvious.

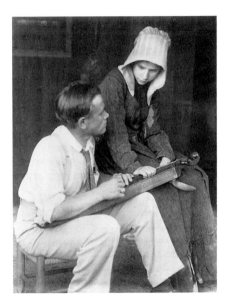

PLATE 41

**Anne May Hensley,
Brasstown,
North Carolina**

Circa 1933–34

Platinum print
20 × 14.9 cm
87.XM.89.82

PLATE 42

**John Jacob Niles
with Blanche Scroggs,
Brasstown,
North Carolina**

Circa 1933–34

Platinum print
20.3 × 15.4 cm
87.XM.89.3

PLATE 43

**John Jacob Niles
with Blanche Scroggs,
Brasstown,
North Carolina**

Circa 1933–34

Gelatin silver print
20.4 × 15.2 cm
87.XM.89.4

The image of the professional laundress, with overtones of the possibly illicit conduct of working women, was exploited in the nineteenth century by Edgar Degas and illustrators of the popular press. Ulmann's ironer (pl. 41) does recall an Impressionist pose, and the setting, which appears to be the same as that used in the compositions with Niles and Blanche Scroggs (pls. 42–43), creates an enigmatic atmosphere.

Scroggs, the young woman Ulmann employs to set up an intriguing dynamic with Niles, was very likely the daughter of a local grocer, Fred Scroggs, and the granddaughter of the legendary "Uncle Luce" Scroggs, donor of the land occupied by the John C. Campbell Folk School. Of the eight portraits Ulmann made of her, four present her alone and at work, either ironing or peeling potatoes. Another series of four, two of which are these images, show her in a close, ambiguous situation with Niles. The superficial intent, at least, appears to be that Niles is working with Scroggs, an accomplished singer, to copy into his notebook the lyrics of folk songs passed down to her. In many instances Ulmann did record Niles, notebook in hand, with local musicians. In this series, however, the interest in folklore has to be read as secondary. A more significant and complex explanation offered recently is that Niles, through Ulmann's manipulation, is standing in for the artist, who gazes at her model. Also provocative in the sexual tension it communicates, this series may thus be seen as autobiographical on several levels.

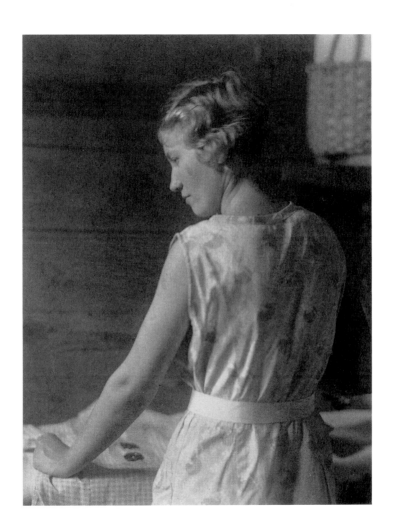

PLATE 44

**Jean Thomas and
John Jacob Niles,
Near Ashland,
Kentucky**
Circa 1932

Platinum print
20.3 × 15.2 cm
95.XM.26

Niles is pictured here with Jean Thomas
(née Bell), who was born in Kentucky
and first collected folk music on her circuit
travels as a court stenographer. She even-
tually decided to work in the entertainment
business as a promoter of Southern music
and an organizer of annual folk music
festivals. She founded the American Folk
Song Society (to which Ulmann belonged
and whose advisers included the poet
Carl Sandburg, author of *The American
Songbag* [1927]) and wrote nine books
about the folklore and music of Kentucky.

Ulmann rarely attempted to compose
portraits by employing an entire archi-
tectural facade, but here she seems to have
done it in order to portray a movement—
the American folk music revival—rather
than an individual. It is, however, typical
of her more purely architectural studies in
that it exhibits a sense of compressed space
and is constructed of tightly organized geo-
metric forms from the built environment.
Unlike most of the Getty Museum's holdings
of Ulmann's work, acquired from Niles's
family, this print came from Eaton's heirs.

PLATE 45

**Rosie Day, Wife of
the Fiddler James
William Day,
Ashland, Kentucky**

Circa 1928–34

Platinum print
20.4 × 14.9 cm
87.XM.89.79

PLATE 46

**Weaver and Pianist,
Ashland, Kentucky**

Circa 1928–34

Platinum print
20.1 × 15.3 cm
87.XM.89.69

These two women, who according to Niles's notes were related by marriage, may have been photographed by Ulmann in 1928 on the first of her seven trips to the South with Niles. On that trip they spent a good deal of time in Kentucky, where he met with musicians and folklorists, including Jean Thomas (pl. 44) and the fiddler James William ("Blind Bill") Day. Thomas was promoting Day as "Jilson Setters, the singin' fiddler from Lost Hope Hollow." She arranged for him to record for RCA and to perform in New York and London. Ulmann documented Setters and his wife, Rosie Day, in some twelve portrait views, one of them being restricted to his hands and his instrument. The other woman was also pictured with her instrument—the piano— although here Ulmann was apparently more interested in the polka-dot dress that defines her shape. Day's image also appears to be a study of local dress, both traditional— in terms of the dark sunbonnet—and current—as reflected in the floral-patterned housedress that seems to light her melancholy face from below.

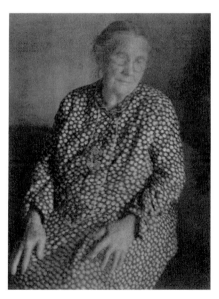

PLATE 47

Fiddler, Probably
Ashland, Kentucky
Circa 1928–34

Platinum print
21.4 × 16.3 cm
87.XM.89.88

Possibly made during one of the American Folk Song Festivals held near Ashland, Kentucky, this portrait appears in one of the proof-print albums at the University of Oregon. Seven images of this musician can be found there, including a view of him posed with Niles. Other portraits of men performing with guitars or dulcimers are also annotated as "Ashland." The fiddle, probably handmade, is as much the subject of this composition as the face of this "authentic" member of the folk music movement.

In the "Mountain Music and Hand-made Instruments" chapter of his *Handicrafts of the Southern Highlands,* Eaton states that "the relation of handicrafts to mountain music is much closer than one might at first think." He discusses the derivation of local ballads and the gatherings where they were sung, including the more recently organized music festivals and the more traditional social gatherings, like neighborhood picnics, county fairs, and fiddling and singing contests. He also remarks on the variety of handmade instruments that had been passed down in Highland families—dulcimers, banjos, flutes, piccolos, pipes, zithers, horns, and bugles—and describes the fiddle as the instrument "probably played by more people than any other."

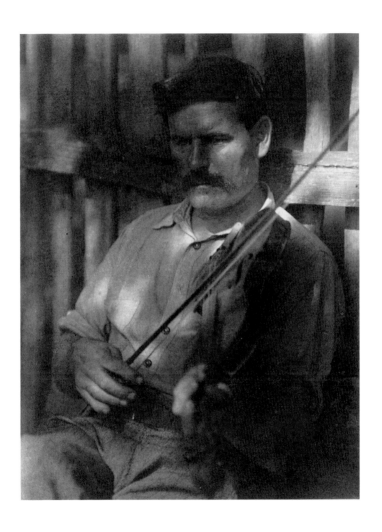

PLATE 48

**Teenager with
Sleeping Child,
Linefork, Kentucky**
Circa 1930–34

Gelatin silver print
20.3 × 15.2 cm
87.XM.89.157

An unlikely composition juxtaposing the
darkness of a log cabin interior with
unorthodox lighting and a confused sense of
exterior space, this "discovered" moment
between an exhausted toddler and a teenage
girl (perhaps the mother or a sister) is a
remarkably sensitive depiction of innocent
trust and the maternal impulse. Its realism
contrasts sharply with Pictorialist Gertrude
Käsebier's more academic portrayals of the
mother-and-child theme and foreshadows
the documentary style of later New Deal
photographers, such as Dorothea Lange,
who reported on the human element of the
Great Depression.

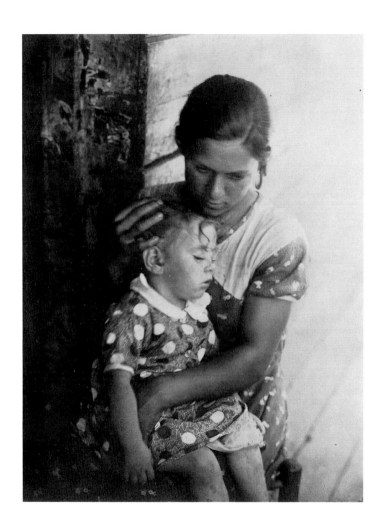

PLATE 49

May Apple
May 6, 1934

Gelatin silver print
20.3 × 15.2 cm
84.XP.460.3

Unfortunately, Ulmann's death in August of 1934 prevented her from editing and printing the negatives made on her last Southern trip, so this picture must be viewed as one she visualized on the ground glass of her 6 1/2-by-8 1/2-inch view camera but never saw as a positive print. It is not known, then, how she would have judged its success.

Ulmann's work with flowers seems to have come from an experimental impulse as well as a botanical interest. She photographed wild cherry plants, dogwood blooms, and the Kentucky rose as she traveled in the mountains; back home in Manhattan, she made some unusually animated compositions with cut flowers. Perhaps her interest in this subject was fueled by the appearance of work by Imogen Cunningham and

Albert Renger-Patzsch, proponents of a "new objectivity."

Ulmann also made two other plant studies (of a yellow hawkweed and a purple iris) on May 6, 1934. The blurred movement of the leaves in this print creates a ghostly effect that highlights the brief life of this fragile blossom.

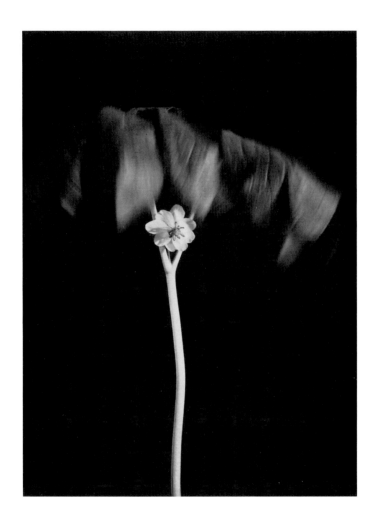

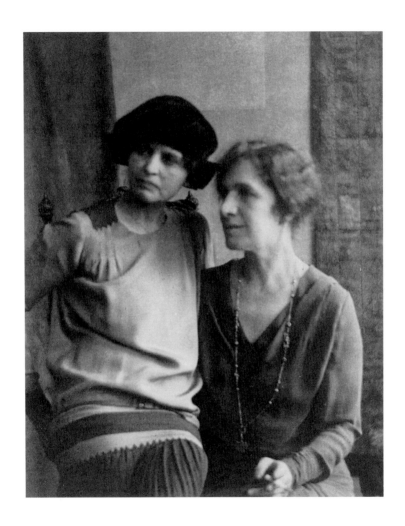

Attributed to Doris Ulmann.
Self-Portrait with Julia Peterkin, circa 1930.
Platinum print, 19.6 × 15.5 cm.
Collection of the South Carolina Historical Society.

Between Two Worlds:
The Photographs of Doris Ulmann

Charles Hagen: Let's start with *Harbor Scene* (pl. 1), which will allow us the opportunity to talk about Doris Ulmann's early history and set the stage for a discussion of her work.

Judith Keller: This is a platinum print that probably was made at Gloucester Harbor in Massachusetts in the late teens or early twenties. It perhaps was created on a trip Ulmann took to New England with her husband, Charles Jaeger, who was an amateur photographer. Landscape was something that both of them seemed to be attracted to, especially when they were under the influence of Clarence White.

William Clift: How did Ulmann become interested in photography?

JK: As far as I know, she started using a box camera around 1902 or 1903.

David Featherstone: Ulmann was born in 1882, just at the time when the Kodak camera was being introduced. Photography became a major hobby of people in this country. I'm sure that the Ulmanns, as a rather well-to-do family, had a Kodak at some point.

My understanding is that Ulmann's real interest in photography began while she was studying psychology and law. There's a reference to the idea that photography gave her something to do with her hands for relaxation, something away from her academic work.

JK: Ulmann attended the Ethical Culture School between 1900 and 1903. Lewis Hine was teaching there, but he wasn't teaching photography.

DF: That's right. He didn't actually begin photographing until about the time she graduated. He was teaching botany. She may in fact have taken classes from him, but they weren't photography classes.

CH: Did she study at the Ethical Culture School in the same group with Paul Strand?

JK: No, Strand followed her. He was there from 1904 to 1909. It's interesting that they both attended this school. He would have had the exposure to Hine's photography club and to his teaching.

Weston Naef: Maybe we should say a few words about the Society for Ethical Culture, which was founded in New York in 1876 by Felix Adler. It was a religious and educational movement that played a prominent role in social reform through settlement house organizations. At the school Ulmann would have been taught the doctrine of equality among people of different races, creeds, and classes. This, of course, figures prominently in her photographs.

JK: Adler was also one of the founders of the National Child Labor Committee, which would sponsor some of Hine's finest work, much of it done in Southern mill towns after he had resigned from teaching.

DF: I think Ulmann's first official training in photography came from White at the Columbia Teachers College, then later when he had his own school.

CH: Was she ever involved in the Camera Club of New York?

DF: She was involved in White's organization, the Pictorial Photographers of America, but that came a little later, in the mid-teens.

JK: White founded the group about 1914 or 1915. Its annual journal was called *Pictorial Photography in America.* Ulmann and/or her husband had pictures in every one of the issues. The Jaegers and the Whites had a pretty close relationship. Ulmann evidently met Jaeger through White's classes, and Jaeger was the Whites'

family physician. It was more than a student-pupil relationship; Ulmann and White remained pretty close until his death in 1925.

WN: It might be useful to place Ulmann in the microhistory of American photography, because she falls in a very interesting position. Just to recite the pertinent details: Alfred Stieglitz published the last issue of *Camera Work* in 1917, and that is considered a turning point in American photography. That last issue contained the first photographs published by Strand, along with Stieglitz's declaration that a new time had come. White was one of Stieglitz's foremost collaborators until they had a difference of opinion and moved in different directions. By rights, Ulmann could have been included in the Photo-Secession movement along with her older contemporaries, Gertrude Käsebier and Anne Brigman, but she wasn't.

We see in this picture more of White's influence than Stieglitz's. Ulmann's work at this time was very much grounded in Pictorialism, but she is also on the cusp of Modernism.

CH: I think your mention of Brigman is quite appropriate here. This somewhat ordinary genre scene has a most amazing tree. It's a very expressive, twirling, dancing tree, with intertwined limbs. I see it as a figure with upraised arms.

JK: It's interesting, too, how even with a soft-focus lens, which I'm sure Ulmann was using, she managed to create a very flat composition. There is, I think, definitely an Asian aspect to it that may have been due to the influence of Arthur Wesley Dow, who taught in the art department at Teachers College. Dow emphasized the tradition of Eastern painting in his teaching and his textbooks. He is somebody Georgia O'Keeffe studied with for a while and admired very much; I think there were other Pictorialists who borrowed from him too.

CH: Did Ulmann do her own printing?

DF: She had a darkroom in her apartment. She was very insistent about being in control throughout the process.

CH: Do you think she was interested in the house for itself or for the shadows that fell on it? In a number of her Sea Islands photographs the shadows are such

an important part of the picture. I wonder if that was already part of what she was thinking about when she saw a scene like this.

DF: I've always felt that the interplay of light and shadow was something that connected Ulmann to White's Pictorialist concerns. There are photographs of shadows on walls that show up throughout Ulmann's next ten or fifteen years of work.

JK: We should probably say that at this point Ulmann was not only photographing landscapes, she was also making figure studies, especially of laborers, dockworkers, fishermen, and other tradespeople she discovered in New York. She was traveling around New England and making portraits there as well. She actually seems to have been known more for those genre pictures in the early years, but that clearly wasn't all she was doing.

WN: If we were to know Ulmann's work only from this photograph of Gloucester Harbor, I think we would see promise but not genius.

DF: One aspect of this picture that foreshadows what we see in her later work is the very considered structure of it. She put her camera in the precise place it needed to be for the tree to separate those two buildings and for the boat to be highlighted through the fork of the tree. That's very intentional.

WN: The photographer's choice of where to stand is one of the few aspects in the making of a picture over which he or she has total control, and the method of harnessing this element is one of the defining factors of style in photography.

CH: I think you can read this kind of picture psychologically, which opens up some interesting dimensions for meaning.

JK: At Columbia University, Ulmann studied psychology, and at both the Ethical Culture School and Columbia Teachers College she trained to be a teacher. Her original professional goal seems to have been to teach psychology. Do you think she had her own training in mind when she composed this picture?

CH: I don't know. But it's interesting to think about how much weight to give that kind of suggestion.

WN: I am interested in the suggestion that there are deeper meanings behind a picture that seems on the surface to be chiefly decorative.

CH: If you read the tree in a figurative way, then you can start to look for comparable meanings in other elements of the picture.

WC: Do you think the branch hanging down at the tip of the boat is intentional? I do. I don't think of it as having any meaning, but she was involved in photographing something that appealed to her. She built a picture around that attraction.

WN: She has made some very deliberate choices. She's made sacrifices in order to achieve content. For example, she sacrifices the entire right edge of the building in order to get the shabby little structure at the left. Why did she make this compositional choice? You're right, Bill, that she built the picture, but how can we interpret its meaning?

WC: Well, maybe it comes out in spite of itself.

WN: Let's refer to a photograph of your own, Bill. You made a picture once that strikes me as being very much like this. It's a picture of a tree with a swing in the foreground and a magnificent landscape in the distance. Only you can tell us whether that swing has any greater meaning than being a formal element.

WC: Well, again, I think that comes in spite of itself. In spite of me, the meaning comes out; not from my mind as an intention. Something comes out instinctively. That may be where the strength of the picture comes from, but it's not necessarily something I'm thinking about at all, as meaning, when I'm making a picture. In the case of this image, if the boat had been twenty yards down the river someplace, would she still have made the picture? Would there still have been a scene that caught her eye? I think from looking at a number of things that she did in this area that very possibly she would have.

CH: This is a basic question of photographic criticism. How much weight do you give to the intention or symbolism of any one picture or any one aspect of a picture? With photographs you can always defer intention to the camera or to the world: it was there, and that's why it's in the picture. In a sense, that's attributing less ability to the photographer, implying that he or she didn't have any way to

edit things out. If you think it's a significant picture, however, you have to accept that it is what it was meant to be by the photographer.

JK: This is a much more complex composition, especially for a landscape, than is typical in Ulmann's work. Maybe she was trying this sort of thing to begin with but then decided she preferred or was better at simpler constructions. Especially with her portraiture, she developed a pretty severe kind of composition.

DF: She carefully arranged the portraits, even to the point of moving objects around on a mantelpiece from one exposure to the next. It must be a real challenge to approach nature in the same way, to construct nature.

JK: In the 1920s Ulmann appears to have concentrated on portraiture much more than she had earlier. Let's look at her portrait from around 1929 of the Mexican muralist José Clemente Orozco (pl. 10).

Clearly she was photographing him either in his studio or perhaps in a gallery where he was exhibiting his work. I suspect she came to know him through the dealer Alma Reed, who was responsible for promoting Orozco's work in the United States, particularly in New York. Ulmann had a one-person show at Reed's gallery, the Delphic Studios, in 1929 and another one there in 1933.

The Getty collection has two different portraits of Orozco from this sitting. This, I think, is the better one. He's clearly someone who was kind of a darling of the art world, as Diego Rivera would be a few years later.

WC: It seems to be one of her strongest pictures of a well-known person.

JK: From the late teens on she photographed a lot of artists, writers, and musicians in New York. They usually came to her studio, but sometimes she went to them. Maybe she had a special liking for Orozco because he came from Mexico. His work was something that represented a more populist or democratic art, although in terms of choosing which artists to photograph, their philosophy of art didn't seem to matter that much to Ulmann.

WC: It's an extremely precise picture, with the placement of his hand and the repetition on his shoulder at the left edge of whatever that jagged shape is in the right background.

Ron Pen: It strikes me that such full-frontal portraits are much stronger than the profiles. When he's looking directly at her, she gets something out of him that seems much more than just a portrait.

Susan Williams: Well, he has almost a sexual intensity in this shot. I may be reading this in, because Julia Peterkin, Ulmann's friend and collaborator, wrote a play after she attended a cocktail party for Orozco at Ulmann's apartment that suggests that Orozco tried to seduce Peterkin. There are actually two different accounts of it. Reed talks about Ulmann setting up a meeting between Peterkin and Orozco. Orozco decided he wanted to paint Peterkin, and they had this sort of sexual banter. He painted an incredible portrait of her, but it's not very flattering; probably one of the most realistic portraits of Peterkin I've ever seen, very strong and almost African, with androgynous features and kinky hair.

JK: Wasn't this about the time Peterkin and Ulmann first became acquainted?

SW: I would definitely say they were friends before this party, which was held in November 1929. I think they had to have been friends to be setting each other up in this flirtation! Reed talks about getting these portraits of Orozco, which she says were the best ever taken of him, at the cocktail party. They were apparently made before the party and brought to it as a present for his forty-sixth birthday.

WN: We have made a big jump here! We've moved ten years in time, from the point where Ulmann was a serious amateur photographer practicing a style with that wonderful liberation from any preexisting styles that all amateurs have, to a position of being a photographer for hire—someone who was expected to fulfill, I assume, the commercial objectives of book jacket portraiture. Do you consider her a professional portraitist motivated by its income potential?

DF: She was fulfilling that function in a lot of ways, but she never charged for making such photographs. Clarence White, Jr., used to describe her as shy and retiring. She wasn't the type of person who would go up to Orozco at a cocktail party and make her own introduction. Knowing, however, that he was going to be in town, and especially through the connection with her gallery, she might arrange to make his portrait as a way of meeting him. It was her role as a photographer that gave her entrée to all these people in literature and the arts. And some

of the photographs did end up on book jackets. Her photographs of writers were included in a magazine called *Wings,* which was the mailer for a book club, the Literary Guild of America.

JK: From my understanding, she contacted authors, especially those whose work she had read. She read a huge amount and collected a great number of books. She would contact people after she had become familiar with their work and ask if she could photograph them. There was no money involved. I think that she wanted to get acquainted with them on a certain level, but I don't think she became very friendly with many of these people.

RP: We also need to remember that she really didn't need all that much entrée, because she was an independently wealthy woman who was used to moving in those circles already. She was hardly impressed when she visited the Roosevelts at the White House in 1934. Money was just not a currency for her as far as her photographs were concerned.

WC: My sense is that she started out wanting to meet famous individuals, but her inner attraction to these people was because of their substance. She ended up going out to the Appalachian people and the Shakers, but the original impulse was the same—people of substance, of intense humanity. She used photography as a tool to get to know them, but it probably didn't extend much beyond the time of the sitting. She was almost using the camera to understand her subject for herself. It's like a method as opposed to a friendship. Instead of knowing somebody by sitting down and talking with them, you're photographing them, and you dig and dig and dig until you've extracted something essential!

DF: I don't think we should give the impression that she only photographed well-known people before she started photographing people who were not well known, because there are portraits of individuals on the docks of Gloucester Harbor from the late teens and early twenties. Perhaps it's just because she was spending more of her time in New York City that makes it seem that she was doing more of these portraits of prominent personalities during the period.

CH: She obviously learned a lot in that decade. Compare this complex and powerful portrait of Orozco with one from 1920 of Max Broedel, who was on the Johns

Hopkins University medical faculty (pl. 7). It's not a very complicated kind of portrait. He's shown in profile, has his hand on his knee, and is holding a cigar. There are certain elements and props that you would expect to see in a portrait of a powerful man. The Orozco picture is much more confrontational. There are more subtle formal elements to it, like the way that his hand echoes his mustache, and the way that they both counter the curve of the background, the jagged edge there. I'm also struck by the fact that the focus is halfway between the hand and the eyes, not on either.

JK: It's on the sliver of white of his shirt. I think of that as quintessential Ulmann, in the way she used the platinum process. She always seems to have set things up so that there was a complete range of grays and then, in at least one spot, a really white area. It succeeds very well in directing your attention here to the very middle of the composition. It also emphasizes the tonal range that platinum has; she exploited that very well, I think.

WN: It's interesting that Ulmann is photographing in a soft-focus fashion and using platinum printing at a time when Edward Weston and Paul Strand had finally decided that gelatin silver materials were best equipped to translate their particular vision into the final printed form.

CH: Is that one of Orozco's paintings in the background?

JK: I suspect it is his work. It looks to me like a charcoal drawing or an oil study. It doesn't look like a finished painting, but ink drawings and murals were really his medium. This reminds me, in a way, of the photographs that Stieglitz made of O'Keeffe and others in front of O'Keeffe's paintings.

CH: It's interesting to talk about this in relation to Stieglitz's pictures of O'Keeffe, not only because he posed her in front of her paintings but also because he focused so much on her hands. If you think of that in relation to this picture, you can see how Ulmann juxtaposed the artist with his work and how his hand is used as an expressive element.

RP: That is something that Ulmann always does. In every photograph I look at what is in the person's hands, and it's either a tool or a pipe or glasses or some-

thing resonant of their craft. If there's nothing in their hands, then there are tobacco sheaves nearby to let you know that the person is a tobacco cutter, or whatever. Here it had to be a painting. She's very aware of what's going on in the hands, because they are the center of work and she was so fascinated by work.

WC: His hand isn't just there, it's in mid-gesture, almost as if he were painting.

SW: And you can almost sense that the other arm is missing. Orozco lost it in an accident many years before.

JK: She also captured this grocer in the middle of his work (pl. 18). This is a picture of a vegetable stand, probably from the late 1920s.

CH: I'm curious about where her interest came from in recording common people, or types of common people, like this grocer. This seems to have been an ongoing theme in her work throughout her whole career.

JK: I guess I would attribute some of it, not knowing much else about her family aside from her father's wealth and success in New York, to the background that she took away from the Ethical Culture School, which had a very strong orientation toward the working man. In fact, it was originally called the Workingman's School, and ethical behavior rather than religious ritual was stressed. The first urban settlement houses were started on the East Coast by the people involved with the Society for Ethical Culture. That's something that relates to what Ulmann did much later on, when she photographed at rural settlement schools in Kentucky and North Carolina. Her husband started a hospital that was essentially a free clinic at which he offered his services to people hurt in industrial accidents. I don't know what was being taught at the Ethical Culture School when she was a student there, but the fact that somebody like Hine would have been teaching any subject there is significant. His primary interest was sociology, and I think the school's impact on her, and on him, too, for that matter, can't be discounted.

DF: I think there's no question that that type of social philosophy influenced most of what she did. We know that she started photographing individuals on those early trips with the Pictorialist group or with her husband. In the mid-1920s she

produced other series in the Mennonite and Shaker communities in upstate New York that were published in the *Mentor* in 1927.

The location of her vegetable stand series is identified as Bleecker Street. Since she lived in New York City her whole life, I'd have a hard time dating these pictures any more specifically than from the mid-1920s to the early 1930s, just because she would have had access to that subject matter at will. It didn't require any special trip to find it.

RP: I think in part the Bleecker Street photographs may be connected to Johnny Niles, who was her friend and companion beginning in the mid-1920s. He lived there and was writing an opera at the time called *The King of Little Italy*. In his notebooks he talks about the grocers and vendors who are characters in this opera.

JK: If this was taken near where Niles was living, he may have known this fellow.

WN: So Niles played a very important role as the interface between her and the rest of the world. It wasn't just the Appalachian world that he was born into; as we're seeing here, it was also a world much closer to home.

RP: Niles was a real chameleon. He studied in France, at the Schola Cantorum and the Université Lyon, as well as at the Cincinnati Conservatory. He was fluent in more than one language, well-read, romantic, and comfortable in a tuxedo, but he also used to call himself, "Aw, shucks, just Johnny Niles, the Boone Creek Boy." He could play the folk tradition against the art tradition, and that's what became his successful performance routine. He could relate to Doris and that milieu in a somewhat sophisticated way, but then he could go out and sing ballads on Cutshin Creek as well.

WN: What was his age in relation to hers?

JK: He was ten years younger. He was born in 1892 and died in 1980.

WC: There's an interesting parallel to Laura Gilpin. Gilpin had a friend, a nurse who worked with the Navajos, who provided her with entrée to the Navajo people. So you need somebody of that nature.

JK: Margaret Bourke-White had Erskine Caldwell, and Dorothea Lange and Paul Taylor worked well together in that regard. Walker Evans had the Tennessean James Agee to strike up acquaintances with tenant farmers in rural Alabama.

WN: This photograph is typical of the pictures that grow in their content as you are given the opportunity to study them. For me, the most interesting elements are the big, blurry mass directly behind the man, which looks like somebody bent over sorting vegetables, and the figure leaning against the back wall, who is so out of focus that he almost becomes a ghost. The picture dynamics start with the background figure and move through what you would have to call disfigurement, but in this particular case, because it is the transition from background to foreground, it works pictorially.

CH: I don't think this photograph compares well with many of her other pictures. It seems so typical, so similar to a lot of other people's work. Also, there's a distance between the photographer and the subject. The grocer seems to be somewhat suspicious of the encounter rather than investing himself in the whole situation.

WN: You also have to wonder about some of the social dynamics. This must be the proprietor of the store, otherwise he wouldn't allow so much time to be wasted in this frivolous activity. He's watching her make the picture—as Charles says, somewhat suspiciously—almost more suspiciously than most of the people she photographed in Appalachia.

RP: You've raised an interesting point that I think any portraitist needs to take into account, which is how you gain the confidence of your subject. Bill was talking before about how she was able to extract the essence of a sitter's character—her Appalachian photographs are remarkable that way. As someone who collects material from older traditional musicians, it's taken me ten years in some cases to get to the point where I can get the music from them and talk with them honestly, where they won't tell me lies just because they know I'm an outsider.

The key for her in a lot of those photographs may have been her personality, which was not flashy or flamboyant. Part of it was also Niles's ability to sing with them first, to establish that he was just one of them. I think a lot of the openness she captures in those photographs is there because of Niles. It's a very tough

thing to do, and it's remarkable that she was as successful as she was at it.

JK: Even though Ulmann and Niles met in 1925 and became friends in New York, she didn't actually hire him as an assistant until 1927. They didn't start traveling together until at least 1928. She had journeyed to Virginia before meeting him, but I don't know if she had been any further south. When she started traveling with Niles, they visited people he considered important sources for what was being called traditional American folk music. She so often photographed the people he knew of as contacts or wanted to have as contacts that it's hard to separate that from her own purposes in finding people to photograph. He had been collecting folk music since he was a teenager.

RP: Niles was born in Louisville, Kentucky, but moved to Inverness Farm in rural Jefferson County near the city of Portland in 1902. He was really more of a country boy. Portland, now a suburb, was then a larger city than Louisville. It was the first place boats would come to on the river before they got to the falls, and then they would have to portage around those falls to get to Louisville.

The kin on his mother's side, the Adamses and the Reisches, were fairly well-to-do. Jacob Augustus Reisch had a saloon and warehouse and grocery. He made his family's money by selling liquor, by taking it down to where they were building the canal that enabled boats to get around Portland and go directly to Louisville. His father's family was where the more "folk" elements came in. His father was a square dance caller and sheriff who knew a lot of traditional music.

Niles started traveling while he worked for the Burroughs Adding Machine Company, shortly after graduating from DuPont Manual Training High School. He traveled throughout the rural parts of eastern Kentucky in the mountains. That's when he really began collecting his material. Then, World War I intervened.

JK: I believe he collected songs while he was in the service, too, and later published them.

RP: Yes, he did two books: *Singing Soldiers* (1927), songs of the African American tradition, and *Songs My Mother Never Taught Me* (1929), representing white doughboys.

WN: Here we see Niles dressed in knickers with smartly polished Oxford shoes and high socks (p. 115). He wears suspenders and a white shirt, has hair that is cut fashionably for the time, and is seated on a low bench with his knees in sort of an insecure position. Resting on the ground in front of him is a stack of papers, probably used to record songs. This picture is full of body language, which is something Ulmann seemed to cultivate in her subjects.

RP: The clothes are an interesting point. The way he was dressed was a direct reflection of the way Ulmann wanted him to be dressed. She was very good about buying all of his clothes. She wanted him to look "right" if he was going to be "on her staff." When he got his clothes muddy falling down a ravine or off a horse or whatever, in the next day or two a new shipment would miraculously arrive from New York. They would give the old garments to some of the nearby inhabitants who were in need of clothes.

CH: How did they meet?

RP: Niles had heard about her from Carl Engel, who was head of Schirmer Music. Engel suggested that Ulmann might be someone Niles should meet, and he filed that away for reference. He was not above going to visit people and using letters of introduction. I gather their real meeting was at the Grand Street Follies. The show she had wanted to see on Broadway wasn't playing, so she went down to see one at Grand Street. There Niles was in three little skits, I think, playing Woodrow Wilson in one of them. She went backstage and met him and thought he was the sort of person she needed to gain entrée into Kentucky.

DF: A few minutes ago Charles asked how Ulmann developed her interest in photographing folk types. It might be helpful to look at what was going on in the United States after World War I, when there was an influx of immigrants from Eastern and Southern Europe. There was a kind of nativistic movement, a retrenchment among the establishment in the cities, that was looking to the Appalachians for the Anglo-Saxons, for the Scotch-Irish immigrants who had settled there. I don't know to what extent Ulmann bought into this—maybe she was just influenced by the whole direction of public concern—but the June 1928 issue of *Scribner's Magazine* printed a group of her pictures called "The Mountaineers of

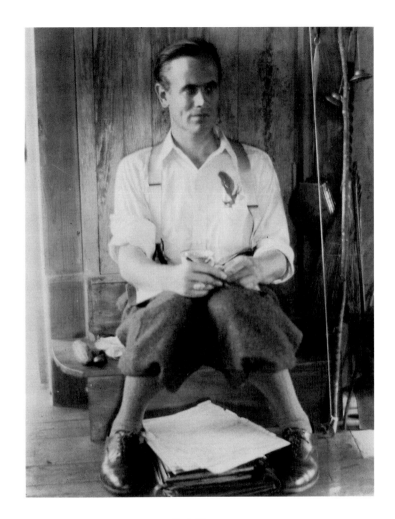

Doris Ulmann.
John Jacob Niles with Notebooks, Brasstown,
North Carolina, circa 1933–34.
Gelatin silver print, 20.3 × 15.2 cm.
87.XM.89.12.

Kentucky." In an editorial about her portraits, the *New York Times* made the point—remember that 1928 was an election year—that Ulmann's pictures represented the great numbers of "Republican votes" that were in the mountains. The editorial commented, "There are no more clearly pedigreed Americans than they."

JK: Yes. In the early 1920s restrictive immigration laws were being passed. This was not only a way of thinking; action was being taken. It was a postwar reaction, and it was pervasive.

CH: From what I've read, there was also a general feeling, among intellectuals and artists, that somehow America was different from the rest of the world. The U.S. felt that it had saved Europe. Alfred Stieglitz founded An American Place, and at his Anderson Gallery show he declared, "I was born in Hoboken," that famous statement where he claims himself as an American. A part of that whole movement was trying to investigate the roots of Americanness in that period.

DF: What's interesting in all of this is that while Ulmann did become a part of this larger movement to some degree, her own background was German-Jewish. She didn't really seem to have pursued that heritage.

CH: Again, I find the parallel with Stieglitz to be interesting. He was from the same background and yet was so concerned with finding unimpeachably American artists. He hailed O'Keeffe and John Marin as true American artists. This is a period when, for the first time, visual artists and writers could live in this country.

WN: Speaking of Stieglitz and O'Keeffe, let's look at *A Study of Hands* (pl. 17), which has always struck me as an interesting and puzzling picture. I have always loved it for its staging. What was the motivation—art or illustration? To me the photograph has the look of something that may have been made to illustrate a literary text.

DF: This is one of a series of about a dozen prints in the albums at the University of Oregon. They were clearly all done the same day, because Niles is dressed in the same suit. Almost all of them focus on his hands doing one thing or another, like opening a lock with a key or opening a bottle of wine. I think the series is

indicative of a relationship that had developed between them. My guess is that these were done in 1933 or 1934, later rather than earlier in the relationship.

CH: Can I be blunt? Were they lovers?

JK: Yes, by all reports.

RP: I don't think anyone has been willing to say it in print yet. They were extraordinarily close, and he was sleeping in her apartment on a rollaway bed or a kind of mat a lot of the time.

SW: Peterkin certainly believed they were lovers. She talked a lot about Niles after Ulmann's death.

JK: Ron, in Niles's diaries, does he talk about her as a lover?

RP: No, he's never personally reflective in his diaries. For the most part, they document the work that he and Ulmann were doing. With very few exceptions, his is not the kind of commonplace book where someone might write their innermost thoughts about who they're involved with. He was in love with her, that much is clear, but how the word *love* is defined is open to interpretation. Niles was accused of being a gigolo, because he was ten years younger and was kept by her in the style to which she wanted him kept. They were both sensitive to this.

JK: Well, they went everywhere together, too, for a while. They went to the theater, the opera, very public places. Part of the complication was that Niles was already married to someone else, at least until 1932.

RP: He had been separated for quite some time. I think the point at which they probably become more than collaborators was in the last few years of her life, after 1932, when their relationship changed somewhat and they were pretty much constant companions.

CH: I find this a very intimate photograph.

JK: Yes, especially when you see it in the series with all the other poses. She made a huge number of portraits of him, aside from the hand series. She was constantly photographing him.

WC: That kind of relationship between a photographer and subject comes up with Stieglitz and O'Keeffe and also with Edward Weston and Charis Wilson. The camera becomes a vehicle for the development of both a series of photographs and a relationship.

WN: Is Niles a little like the dream husband in the sense that he can literally do everything?

RP: Smoke his own hams, build his own house, carve his own furniture—and give Ulmann as much space as she wanted.

JK: It seems like he would have dominated her, but from his accounts of the way they worked together, that wasn't the case. She was so dedicated to her craft and would stay up all night working. She wanted to maintain this very hectic pace. It appears that she went ahead with what she wanted to do, and he tried to keep up with her. It's almost like the kind of relationship that Stieglitz and O'Keeffe thought they would have when they first got together.

WN: The picture of Niles with Blanche Scroggs (pl. 43) also hints at a relationship. Where was it made and what were the circumstances?

JK: It was done at the John C. Campbell Folk School, near Brasstown, North Carolina. The school had been founded about 1925 by Olive Dame Campbell. Her late husband, John Campbell, wasn't really part of it, but he had spent years on a sociological survey of the Southern mountains for the Russell Sage Foundation, which supported Mrs. Campbell's planning for the school. The purpose of the school was not just to give people in that area a general education but also to revive regional handicrafts. It was designed on the model of Danish vocational schools. Even though the idea was to revive American handicrafts, Olive Dame Campbell, as well as other women who founded settlement schools throughout the South, had traveled in Europe, particularly in Scandinavia. They were transplanting these Scandinavian ideas.

Blanche Scroggs is someone who Niles identified in the Oregon albums. Ulmann photographed her over and over again. It's possible that Blanche was the daughter of Fred Scroggs, who was a college-educated schoolteacher-storekeeper in the area. She may just have been a member of the large, extended Scroggs family.

WC: Niles is much less elegant in this picture than in the other pictures.

RP: He's in his chameleon phase; he needs to fit in with the people around him.

WC: There is enormous emotional communication in this picture. It is direct, without any interpretation being necessary.

WN: This picture is a model of portraiture in its command of pose, gesture, and expression. Look at the odd turn of the shoulder and the twist of the head.

CH: I think of it as being related to that wonderful extended series of Picasso drawings and etchings of the artist and the model. He is writing down the folk song, but it is the same kind of honoring of the model, if you will, that you get in that standard motif of the male artist and the female model, which is both artistic and sexual.

DF: What's happening in this picture, though, is that she isn't singing and he isn't writing. It's the same with the photographs that Ulmann made of craftspeople; they're working, but they're not. Because of her long exposure, because they've been interrupted by her act of photographing, they come into a more pensive kind of pose.

CH: They look to me like actors who have been positioned to create the tableau that the artist wants to present. The sensuality of the scene comes from the fact that it's a staged event rather than a documentary portrayal of the situation.

JK: It also alludes to the art-historical tradition of the laundress. She's the working woman who may be subjecting herself to prostitution in order to make ends meet. Degas and other nineteenth-century artists used this motif repeatedly as an excuse for the representation of young women. Ulmann chooses this very attractive young woman and places her in a room that is probably not even her home, but one of the areas of the school. While she may have done her own laundry, this act of ironing was contrived for the photograph.

CH: I find this extremely rich in narrative terms, but it's a side of Ulmann I don't see very often. In most of the portraits it's more of an undercurrent. For me, the

young woman's gaze is the crucial element. She looks at Niles, and I'm sure Ulmann said, "Look at him."

WN: One of the most interesting elements goes back to something that Judy said a little earlier about who was dominant in the Ulmann-Niles relationship. Ulmann uses her skills to shape the subject before her. This picture seems to be about something other than what appears on the surface.

SW: It's very interesting to hear you say that. I think both Peterkin and Ulmann had the same sort of conflict over the role of the female artist. They thought it was an inappropriate role, but they continued to fill it. They tried to interject a man into their work, which would allow them, as women, to be the subject.

DF: Ulmann did not make many pictures depicting a relationship between two people. In her portraits from the Appalachians or from South Carolina or even from the Mennonite areas, there are few pictures of couples presented as couples.

WC: Here there's a real relationship, a lot of chemistry. It's almost as if the girl is Ulmann.

SW: She sets this thing in motion, and you see a spark between these two people. You wonder if anything developed between them, and if there was jealousy.

WC: Again, I don't have a feeling that Ulmann is intentionally trying to narrate something that exists between them. I think that because something does exist between her and Niles, it comes out as an unconscious expression.

WN: We're witnessing a major collaboration between the artist and her model.

JK: I think part of this has to do with the fact that Niles got more and more involved in helping her decide what to photograph. He talks about her not feeling very well during the last couple of years. I don't know how much he contributed to this composition, but I think his flair for the dramatic may have had something to do with setting up a tableau like this.

CH: Can we talk now about Ulmann's work with Peterkin in South Carolina and how this fit in with the projects with Niles?

SW: As far as I can tell, her travels with Niles and Peterkin didn't overlap much. The first real records I have of her being in South Carolina are late 1929, early 1930, but I don't think she and Peterkin started out with the idea of collaborating on anything. I think the collaboration came at least a year or two later, after their friendship developed.

CH: She had met Peterkin in New York?

SW: Evidently. It was probably associated with Peterkin's having won the Pulitzer Prize in 1929 for her novel *Scarlet Sister Mary.* Peterkin started writing when she was forty years old. She was born in 1880, so she and Ulmann were approximately the same age. She had no interest in writing until a sort of awakening in the early 1920s. She was one of the first people who wrote from a black point of view, although it obviously wasn't really a black point of view, because she was a white woman! Her approach compares very well with that of Zora Neale Hurston, who came later and I think learned a lot from Peterkin about capturing black voices and a black narrative point of view.

Peterkin is best known for having left white people out of the picture completely. The traditional plantation novel treated blacks as a kind of backdrop. They were either comic relief; or evil, during Reconstruction; or servants who were catering to white people's needs. Peterkin did actually write about white people, but she never published any of it. Her gift was writing from the black point of view.

Roll, Jordan, Roll, the collaboration with Ulmann, came, I think, out of some of their trips together. At first they planned a book of Ulmann's pictures, for which Peterkin would write captions. Then, as the project went on and their relationship started to deteriorate, Peterkin decided that it was her book and her writing and that the pictures were peripheral.

WC: Why did their relationship deteriorate?

SW: It was a complicated, love-hate relationship from the beginning. I think it started out almost as a *Thelma and Louise* scenario, with the two women going off on the road to be footloose and free of men, although they still had George, Ulmann's chauffeur, along. In fact, their tastes were so different that they didn't

always enjoy being together. Peterkin would get very irritated with Ulmann for not wanting to go out and do things the way she did. I really think both of them were sort of using each other as chaperons. It was very convenient to have another woman along. You could go out and flirt with men and smoke and drink. When David talked earlier about Ulmann being shy and retiring, I felt I had a little different picture of her! I do think that they used each other.

CH: Could someone describe *Roll, Jordan, Roll?*

WN: It is a collection of writings based upon themes directly related to African American culture in the Deep South, with Ulmann's photographs interspersed.

SW: The book gives the impression that it's all about the Gullah culture of the South Carolina coast, but it cuts a pretty broad swath. A lot of the photographs are from New Orleans and Alabama.

JK: But *Roll, Jordan, Roll* seems to be a collection of stories about one community.

WN: It reads like fiction, but it may not be fiction.

SW: Peterkin's great strength was that she could always make her writing seem like reality. Some of it is absolutely true, while other sketches are either invented or embellished.

JK: Do you know who finally decided which pictures would illustrate the book? Ulmann clearly made many more pictures than were used. The deluxe edition has ninety hand-pulled gravures, while the more modest trade edition has seventy-two lower-quality reproductions.

SW: I don't know. I would have thought that Ulmann or the publisher would have done it, because by that point Peterkin had divorced herself from the project and was just trying to conclude it.

JK: Shall we look at some of the pictures from Lang Syne, Peterkin's plantation? This particular photograph of Maum Duck (pl. 24) was not used in the book. In *Roll, Jordan, Roll* she is more squarely facing the camera, and the image is cropped so that the backdrop is not so obvious. I don't remember any other pictures where Ulmann used a white backdrop.

SW: This woman is probably a midwife. Someone who lived at Lang Syne in the 1930s once told me that she looked like one of the midwives, although she couldn't be completely sure. This picture looks like it's in a church, where cubicles separated with sheets have been set up as temporary delivery rooms.

WN: So what we're seeing here is a midwife who is shown with an aspect of her occupation. Is it an occupational portrait?

CH: Even if this is taken at her place of work, Ulmann is obviously very aware of the wonderful play of light and dark in this scene. There are glowing whites and deep, saturated blacks. It's a very rich image.

WC: The shadow of the hat is very nice in both this print and the one in the book.

WN: That lozenge-shaped shadow hovers on the sheet behind her; it is a tip of the hat to Modernism.

JK: This next picture is a study of a man and boy in a skiff (p. 125).

SW: This is in Murrells Inlet, South Carolina, where Peterkin had a vacation house, a tiny little shack. I don't think Ulmann ever stayed at this place. I think she stayed at Myrtle Beach, which was nearby.

WN: There's something tremendously authentic about this picture and also something quite fictional. The wrinkles in the man's clothes are so perfectly organized, especially those outlined against the water. Ulmann has harnessed these divergent realities in a way that makes truth seem like fiction. These could be actors who are somehow put onto the most perfect possible stage for the story Ulmann wants to tell. A lot is left to our imagination.

WC: I don't think for a second that they're actors. You could not make people have those postures. They are absolutely convincing. She may have put them there; she found them and posed them.

WN: So you are saying that she is really directing.

WC: Absolutely.

JK: If you look at the proof-print albums at the University of Oregon, you see that

she made a series of pictures of this pair. To me, it looks as if she wanted to photograph the whole process they went through in their daily search for oysters.

DF: Right. In fact, there are several in this series where the boat is headed into some reeds and is partially hidden. This suggests that this wasn't just a series of photographs taken where a boat happened to be, but that she actually moved the boat to several different places.

JK: She shows them throwing out nets and putting the boat away at night, the whole process.

RP: She wants people at work.

WC: It's curious, though. In none of her publications does she ever show a sequence of people doing something. She is looking for the single picture, for a formal statement.

DF: But she's looking for that picture within a process. She used the same method in her Appalachian subjects. When I asked the folk singer Jean Ritchie what happened when Ulmann photographed her family, Jean told me that Ulmann would come and say, for example, "How did you used to make soap?" Her family would then get all their soap-making materials out of the attic or wherever they had stored them, go through the soap-making process, and Ulmann would photograph the various stages. At some point afterwards she would select the photograph that best said "soap making" to her, but she needed the series in order to make that selection.

CH: This picture sums up for me a couple of aspects of Ulmann's work. One is that she's a portraitist, obviously. This is a vertical image of what would ordinarily, to my eye, be a horizontal landscape scene. That link, then, takes me to Peter Henry Emerson's portraits of life in the Norfolk Broads, the outer marshes in the east of England, which he did in the 1880s. That brings up Ulmann's position of being, in the whole span of documentary photography, halfway between the Newhaven fishermen of Hill and Adamson in the 1840s and the Farm Security Administration and the documentary photographers of the 1930s and 1940s. She really is halfway between a more Pictorialist kind of attitude and a more political

Doris Ulmann. *Man and Boy Oystering,*
Near Brookgreen Plantation,
Murrells Inlet, South Carolina, circa 1929–31.
Platinum print, 20.3 × 15 cm.
87.XM.89.159.

rendering of the same types of subjects that you get after her.

WC: Do you think Ulmann's real motivation in photographing all these African American subjects was to document cultures that would disappear?

SW: I think I have less of an understanding of her than I do of Peterkin. I see a real autobiographical thrust in Peterkin, and I don't see that in Ulmann's connection with these people at all.

DF: I think the postwar movement we were talking about earlier, which sought Anglo-Saxon tradition, would not have looked at Gullah culture as a passing aspect of American life. I wonder if Ulmann might have. Did she see this as a clear extension of her interest in the white cultures?

WC: I don't think she was interested in white or black. I think she was interested in people who had depth. These people were of a certain kind that attracted her.

WN: Let's look at the picture of the girl in the white dress (pl. 23). Here we have a preadolescent girl who is clearly behaving as a young temptress. I wonder what Ulmann thought about her pose and expression. Did she pose this girl? If so, what instructions did she give to elicit the pose, gesture, and expression that we see?

CH: I don't see her pose as being that of a temptress. There's an element of that, but I also think it's a kind of thoughtful moment, like she's lost in a dream. What do other people see in this picture?

WC: I would agree with that. I suspect Ulmann just said, "Go stand there."

CH: I'm thinking back to the first photograph that we looked at, which had the shadow of a tree on the side of a house (pl. 1). Here we have a person in that shadow. She's obviously posed so that she becomes the tree; the shadow of the tree comes out of her head. It's a very symbolic construction, I think.

My interpretation of the first picture is that it is essentially autobiographical. Is this also autobiographical on Ulmann's part? Is she seeing herself in the person of the little girl? If so, it's a much richer and more accepting kind of image for me than the first one.

It's interesting to me that she took all of these pictures that are symboli-cally autobiographical, but that there is another body of work recording folk types of different sorts. The question I have is this: Are these portraits of individuals or are they meant simply to represent types?

JK: I think they are portraits of individuals. Ulmann was interested in the individ-ual faces, in what kind of a picture she could make with those faces, what those faces told her. She is said to have preferred the faces of older, more experienced people, because she thought more could be read in them.

This picture of a man and his son (pl. 30) and the Ulmann picture that was included in the 1955 *Family of Man* exhibition of a father with two young daughters are both excellent examples of her work. They are very effective in showing a strong bond between parent and child. Even though they are people she may have just met for the first time, she is able to convince us of a strong relationship.

DF: I think this photograph is every bit as much a tableau as the one we talked about earlier of Niles and Scroggs (pl. 43), yet in that one I had a sense of actors involved in a dramatic moment. This picture seems to depict these people as indi-viduals involved in another kind of moment. They have just washed a bucket of berries of some kind. The hand coming in from the side to hold the bucket steady belongs to another son, who appears in other exposures of the scene taken from a little farther away. Both father and son are looking out of the frame, which is typi-cal of these portraits. Ulmann very rarely had her sitters address the camera in the same way that she did with Orozco (pl. 10).

JK: Let's talk, too, about this picture of three basket makers (pl. 32). This is Aunt Cord Ritchie and, we presume, her daughter and granddaughter. She was a bas-ket maker, but she was from a well-known family of musicians.

WC: This is a very composed picture, very stagy in terms of the baskets and where the faces are looking.

JK: They are supposed to be in the process of making the baskets, but they don't really appear to be working. The baskets are props—the girl's, obviously finished, even has a price tag on it!

WN: Look at the range of glances they have. The young girl is looking in one direction, the old woman is looking more or less toward us, and the third is looking down at her hands. Those glances create a dynamic in the picture that, strangely enough, animates it even though it's posed.

WC: You would have to say that this is part of the genius of her methodology, because it's in all of her pictures.

CH: I find this to be a remarkably still picture, not so animated. In part, its interest comes from the almost timelessness of the moment. All three figures are holding their hands exactly the same way on the baskets. They're not doing anything except holding the rim of the baskets. They're not even holding a strand of reed to be fed into the basket!

DF: The fact that Ulmann required at least a second for her exposure meant that they had to hold their hands still. She had to create a pose in which people were working, but briefly not working.

RP: Isn't this the documentation that she's really trying to achieve though? It's a static, timeless moment. Here are three generations gathered about that one craft. It's the kind of thing she would have done for the Allen Eaton handicraft project.

CH: What was the Allen Eaton connection?

DF: During the last two years of Ulmann's life she worked on a project for Allen Eaton, an officer of the Russell Sage Foundation. He was producing a book called *Handicrafts of the Southern Highlands*, and Ulmann's task was to create illustrations for the book. In the pictures of those last two years there are suddenly a lot of craft objects. Part of the intent of Eaton's book was to highlight the objects themselves, so at least two of the three baskets here are arranged to show them off as artifacts to the greatest extent possible.

JK: Eaton not only suggested to Ulmann and Niles what communities they should visit, he also mentioned who they should visit. He probably sent them to see Mrs. Ritchie.

The Russell Sage connection is an intriguing one. The foundation was established in 1907 to further social work in the U.S., and it had earlier commissioned and published work by Lewis Hine, such as that seen in the landmark *Pittsburgh Survey.*

DF: Eaton was able to extend Niles's entrée into these communities. They went to some places where Niles perhaps hadn't been, and with Eaton's letter or previous phone calls, they were set up. Also, Eaton provided her with a shooting script, in much the same way that Roy Stryker did with the Farm Security Administration photographers later.

WN: Do you think Ulmann and Niles had a shooting script of their own?

DF: I think they had an idea of what they were after. The script they got from Eaton was, in part, a list of contacts, who to talk to in such-and-such a town. There was another list of the kinds of crafts that needed to be covered. At one point, Ulmann wrote to Eaton saying she had done x, y, and z and asked him to let her know if there was something she hadn't covered. It wasn't a formal script, but there was clear direction from Eaton.

JK: She wrote frequent letters to him while she and Niles were on the road. It was like Dorothea Lange writing back to Stryker. Lange was very conscientious about writing long reports, and Stryker corresponded with the photographers daily. Those letters Ulmann wrote back are some of the only writings we have from her.

RP: Both Niles and Ulmann catalogued their activities. For instance, Niles wrote: "Friday afternoon, April 20th. Martin family, pig carvers, cotton spinners and weavers, using a hand cotton jenny. Conditions cold but sunny. Saturday morning, bright and cold. John Alexander Meadows, miller of corn and wheat. He operates an overshot wheel. Taken through dogwood and apple blossoms. Saturday afternoon. Luch [*sic*] Scroggs, father of Fred O. and other Scroggs."

WN: Charles and David both mentioned the Farm Security Administration. If she had lived longer, I wonder if she would have found herself involved with Roy Stryker and the photographic survey he directed for the FSA. Her work anticipates some aspects of that project.

DF: I think a lot of that anticipation comes from Ulmann's interest in having her photographs serve a social purpose, in preserving these aspects of American culture.

CH: But did she want to preserve the people themselves? Her work is very different from that of the FSA. The FSA and other 1930s activist photographers were intent on saving, improving, and bringing these people into industrial culture. Ulmann's work almost seems to say, "they're going, they're dying."

DF: Yes, Ulmann is directed more at the present, in a nostalgic sense rather than a progressive one. I think we can say that Ulmann would not have been embraced by the FSA without a change in her technology. The soft-focus, glass-plate camera on a tripod would not have been accepted by the FSA.

CH: I think there's also a generational issue here.

JK: Yes, she was twenty years older than Walker Evans, for instance.

DF: The fact that she was not connected with the photographic mainstream, at least during the productive part of her career, would also have had an effect. Her connections with Peterkin and Eaton were literary.

SW: Would Ulmann ever have allowed herself to be employed in that way?

JK: No. She would have had to send in her undeveloped film to Roy Stryker in Washington. I don't think she would have wanted to be a part of the program.

RP: You know, the closest thing to employment she had was probably with Eaton. One letter from her has a nice, telling comment: "Now about my pictures—I feel that this ought to be all of my pictures as illustrations, or none at all. I would not care to have some of my pictures used and some done by somebody else."

DF: This came at a point when Eaton was becoming impatient with her. She wanted to stay longer someplace to make sure she got everything in one region, and he wanted her to push on to the next location. He had a deadline to meet, so he suggested that they use some other pictures.

JK: In the end, they did use other people's pictures in addition to hers. The book was published in 1937, three years after she died. I wonder if Eaton just decided to go ahead and do what he pleased. I don't know how well resolved the issue was between them.

DF: My understanding from other Ulmann letters is that she had accepted it before she died.

JK: This picture of a teenage girl and a child is from Linefork, Kentucky (pl. 48). It seems more contemporary, closer to Walker Evans's images of the South. For one thing, it appears to be in sharper focus. The soft-focus lens that Ulmann used could render a fairly sharp image, I believe, depending upon how she adjusted it.

I don't think this is a mother and child, but you're led to believe this. The background is also unusual, with this kind of dramatic diagonal disappearing into nothingness on the right-hand side.

WN: I think this is a wonderful picture. If we did not have Ulmann's signature on it, I could easily think of it as being by Dorothea Lange.

CH: This is, again, one of those images that makes me think of Ulmann as looking forward and backward at the same time, caught between two eras. Perhaps there are a number of factors that allowed her to keep working in her own way. Ulmann was aligned with Clarence White, but then she fell out of touch with other photographers. And she didn't have to keep up with new trends, because she was able to live on her own income.

WC: My sense is that she had a visual language with which she was completely comfortable.

WN: She was confident in it, and the results were completely reliable.

WC: She felt that she had a lot of work to do, and she wanted to get that done. There's no reason to do something different if your purpose is not primarily art.

JK: The poses here appear awkward. To me, that's what makes the picture seem even more contemporary. The child is a little too large for the teenager's lap; it looks like she might just fall out of her arms at any moment.

RP: Why did she make this photograph? It is one of the few that we've seen where there is no evidence of work. This is an internal narrative relationship, a family relationship. There's no social point being made. It's really a very personal study.

CH: Yes, I was thinking the same thing. There are the documentary pictures of folk crafts and folk types of different sorts, portraits of people that she met, and then there are these more personal images. I am not sure where this one would fall.

RP: Their dresses are interestingly alike, yet just differentiated enough. Do you think that's intentional?

WN: I think it's probably part of why the picture was interesting for her to make. If you were drawing these two slightly different repeated textile patterns, you'd have to go to great pains to differentiate between the two. For the photographer, this subtle differentiation may become part of the content of the picture.

JK: In this picture of Mrs. Campbell's house (pl. 34) we're back in North Carolina, at Brasstown and the Campbell School. I think Ulmann had visited Brasstown before working for Eaton, but once she started her association with him, I suppose she went back, since this was a center of the craft revival.

RP: They needed staging areas. Niles refers to these trips as "expeditions," as though they were going on a safari with all of their equipment. They set up headquarters in a hotel, and in order to have darkroom space, rented two rooms. They always brought along black darkroom drapes so Ulmann could load film-holders, which set the community to wondering what really was happening. From that community, whether it was Brasstown or Hindman or Penland or Pine Mountain, they then went out into the countryside with their connections from Olive Dame Campbell, or whomever.

I just have to read one little morsel from a letter Ulmann wrote in July of 1934: "Campbell was the wisest and finest woman whom I have ever met."

WN: I am so pleased you read that letter, because as I was looking at this photograph, which I don't recall having studied before, I said to myself: "It's not a particularly interesting picture. Why would she have made it?" With what you just read, however, everything falls into place. This is a picture designed to show

respect for someone who is not present, respect for the person who designed and created this place.

RP: The additional motivation in terms of Eaton's project was to photograph Campbell's house and its array of craft objects. I agree with Weston, though, that the picture succeeds beyond that pure representation.

JK: Most of the things you see in this picture—the coverlet, the wood carving, and the broom—were probably made at the school. In at least one other view of this room, the things on the mantel have been rearranged, so I think that photographing the crafts in this setting was part of the purpose.

CH: I find this very interesting in comparison with some of Walker Evans's photographs in Alabama from *Let Us Now Praise Famous Men,* where he is photographing the same kind of interior, but of a much poorer family, and finding a different kind of beauty there. Here you have the same kind of careful composition, an awareness of the expressive nature of the objects with which a person chooses to surround himself or herself. The photograph is actually fairly complicated in its composition; it makes use of the geometry of the scene in a way I tend to think of as more Modernist than many of the rest of her pictures. There is the sort of chopped-off angle of the footboard, which is echoed by the angle of the bed. The dark-paneled wall is cut out of the surrounding lighter areas of the embroidered hanging and the mantelpiece. Compositionally it's softer than a Walker Evans picture; it still doesn't have that hard-edged geometric quality that you find in his work. At the same time, it's surprisingly more attuned to post-Cubist compositions.

DF: It has that same attention to where you put the camera that we were talking about in the first photograph.

SW: Do you think this bed was ordinarily in that position? For one thing, the bedspread would be awfully close to the fire.

JK: I think this house was probably quite small. Although Campbell was a prosperous New Englander, when she lived here, which she did for many years, she

lived simply in very small quarters. It may be that the space she was living in was not much bigger than the interiors that Evans was photographing in Alabama.

WC: So this is probably totally composed.

JK: It probably is, yes. She has most likely moved the bed somewhat. This relates to her images from the teens that are Cubist in their construction, like the first landscape we saw. I think she worked at that quite a while in the teens and then gave up on it. But then things like this appear.

RP: Do you think part of the resonance that she has with these settlement schools is that in places like Brasstown you have Northerners coming down with a social purpose and preserving this culture, and she's doing the same thing photographically that they're doing in the communities? Most of the people running these schools—like Campbell—are Northern settlers.

JK: I think she identified with a lot of these women. As far as I know, all of these schools, with the exception of Berea College, were run by women. They had almost all been founded by women. I think she respected the work they were doing and wanted to see that preserved and promoted. That's one of the reasons she left so much money to Brasstown. She obviously got along well with Campbell. Ulmann and Niles both enjoyed being there; Niles did a lot of concerts, and she showed her photographs. They seem to have been happier there, from her reports, than they had been in a lot of other places they went.

We should go to the last and most poetic image, from 1934 (pl. 49). Ulmann made quite a few botanical studies, where she carefully identified the plants being pictured. This one of a May apple is unusual in that you see the movement of the leaves. Most of the others are fairly straightforward photographs of plants and flowers.

WN: During our discussion we have pointed to certain elements in Ulmann's work, and Bill has said again and again, "I don't think she did such and such deliberately, it was all intuitive." If that were true for any of the other pictures, then it has to be truer for this one.

DF: It's difficult to draw conclusions about deliberate intent in depicting the movement of the leaves in a photograph like this. If this was done in 1934, she was not able to choose to make this print; it was made posthumously.

WN: You think she never saw the print, then?

DF: She probably never even saw the developed negative. Earlier she had developed plates while she was on the road, but my understanding is that on the 1934 trip she didn't. There were some two thousand plates undeveloped when she died.

WN: If she didn't develop it and never saw it, how do we know this is her work?

RP: I have notes that were part of Ulmann's documentation of May 6, 1934. Here are the things they photographed that day: "Miss Mary Rose McCord, Mountain Worker. Mrs. Hays, age 80, weaver of great ability, will not weave because she cannot sell what she weaves. Polly Ann Anderson, age 68, weaving since she was 14. Still weaving; has a beautiful loom room. Still-life of yellow hawkweed, May apple, and purple iris." That's the last entry there.

WN: I think that listing of subjects from the diary is very interesting, because it tells us that she made time to do these pictures for reasons that only she knows.

WC: She may well not have known how this was going to turn out.

WN: This is a problematic picture for me, because she apparently never saw the negative or a print from it. If Ulmann never saw either element, are we correct in admitting it to the body of work?

RP: Earlier we said that one of the aspects of Ulmann's genius is that she, through the camera, is constructing the image. Through the photograph, through the display of the portrait or the room or the artifacts in the people's hands, she is composing everything so carefully. Can we say just because she didn't develop this that she hadn't already constructed it?

CH: The one question I have about this picture is whether she knew that the leaves would be blurred. If she didn't, it's still a striking picture to me, the way the white stem and the white flower are set against this black background. That,

however, would not be nearly as marvelous and astonishing as this picture is with the motion.

WC: I suspect she knew it had blurred, but I don't know if she intended this.

WN: But once she had seen it, would she have rejected it? Would she have destroyed the negative? That's what we don't know for certain.

WC: I don't think she would have, because there's a lot of blurring in other of her pictures, like that man in the background in the Bleecker Street photograph (pl. 18).

DF: Or as a photographer she may have said, "Well, I hope it didn't blur as much as I think it did," and so she kept it to develop and look at later.

WC: That's one of the wonderful things about photography; you don't always know exactly what to expect.

JK: What do you think about the authenticity of this picture if it was printed after her death?

WC: I think it's authentic, but sort of half and half. It's half our appreciation for it now, because we see something in it. We don't know if she would have seen it, but she was attracted to the subject.

DF: Ulmann made approximately ten thousand negatives that are recorded in the proof books. Since there were about two thousand exposed but undeveloped plates in her studio at the time of her death, if we were to set aside anything she did not see, we would be setting aside some 20 percent of her total output. Most of those are of subjects that, because of her reputation, are central to who she was as a photographer. It makes it very difficult just to say, "She didn't see it, so it doesn't exist."

CH: Either we are generous and say, "Yes, she was a great photographer, she would have recognized the value of this image," or "No, she wasn't, she would have had her own, narrower concept of the kind of picture she wanted to make and would have rejected this."

In order to bring this discussion to a conclusion, perhaps we can each offer some general thoughts about Ulmann and her photography.

WC: I'm wondering what meaning her photographs have for people today. What can we get out of her work except art enjoyment? She had an intent then, but now these can be seen as historical pictures of old-fashioned people.

WN: I acquired these pictures for the Museum because they are such a fine complement to work by other women of her time: Käsebier, Cunningham, and Lange. I believe the Getty collection is the only one where photographs by these four American women can be studied in some depth side by side.

JK: I think part of the value of Ulmann's work is her sense of respect for the people she photographed. You see her respect for them and interest in them as individuals. Olive Dame Campbell and others are now being accused of having taken advantage of these people and exploited their poverty, of coming in and trying to teach them their own craft tradition, or introducing another craft tradition and then calling it theirs.

Ulmann was looking at these people in a different way. It's very much like what you get in looking at Paul Strand's portraits of people, whether they are in the Hebrides or Mexico or wherever. You know he respects them very much as hard-working individuals who have their own traditions, who may be living at the poverty level, but are nevertheless just as worthwhile as serious subjects of photography as others.

Ulmann also tells us a great deal about what women could do at that time if they were very serious about it. Part of what she was doing, the social reform aspect of it, was very traditional in terms of a wealthy woman's role in the U.S., at least in the late nineteenth century. She was also traveling on her own and creating this extensive body of photographic work, however, which was not a common thing to do.

WC: In some ways she was very much like the people that she photographed. She found something that she could do with her hands, the same way they could do what they did with their hands. She didn't just sit and think and talk about things, she made something with her hands. She processed her own negatives, she was involved in the whole process. There's a real honesty in that, and I think she discovered the value of that early in her life.

JK: I also think her own frailties made her feel that she could identify with the vulnerability of these people.

DF: Looking at someone like Ulmann shows how really complicated history is when you go back and piece it together. Her work as an artist essentially disappeared from general view after she died, unlike photographers such as Stieglitz or Weston or Strand, where the critical and historical consideration was almost contemporaneous with the progression of their work. I like to use the phrase that Ulmann was "on the cusp." She was trained in Pictorialism, but much of her ultimate motivation was in more of a documentary mode. She was using what was essentially outdated equipment, and insisted on using it to do work that might actually have been better served with different gear. But she had this conception of what a photograph should look like and how it's done. All that becomes very complicated when it has to be reconstructed.

WN: There's another element, too, that we can't forget, and that's how important a long life is to a reputation. Ulmann was deprived of the pleasure of reaching a ripe age and being revered for having been a pioneer in her field.

RP: Before today I looked at Ulmann's pictures for what they would tell me about the subjects she photographed, but this discussion has helped me to see that the images are in fact autobiographical. The subjects reflect her instead of the other way around. I now appreciate her life a great deal more for that. It's remarkable. Even in the things that were focused on a mission of social documentation, or for Eaton's book, or for Peterkin's book, the autobiographical content is still reflected in the vision she had.

JK: *May Apple* is a very appropriate image to see last. It's like an elegy for Ulmann.

RP: It's an early death, but it's spring too.

WN: Photography is a kind of poetry. This picture reminds me of the verses of Emily Dickinson.

CH: I think Ulmann was a figure out of step with her times in a lot of ways, and that led to her critical neglect and disappearance from view. If she had been born

ten years earlier, she probably would have been part of Stieglitz's circle, and we would have known of her along with Gertrude Käsebier and Clarence White. If she had made the shift to Modernism and lived ten years longer, we would have known her through Beaumont Newhall's history, because she would have been featured prominently in that. She was, as David said, on the cusp, in between.

At the same time, because of that, she avoided some of the traps that people in both of those groups fell into. She avoided the sentimentality and overly symbolic interpretations of the Pictorialists. She also avoided the more dogmatic, ideological messages of some of the Modernist documentarian photographers.

We can now look back, at the end of the period of the dominance of Modernism, and say that her approach didn't fit in with the prevailing style of her period; it had its own integrity and strength. She really did present these subjects with a great deal of respect and dignity and deep emotion. We can also notice this very strong autobiographical element, both in her making of the pictures and in the pictures themselves. She's an extremely interesting figure, in part because she doesn't fit into the accepted critical categories.

WN: Susan, would you like to have the last word?

SW: One of the more prosaic parts of her importance, but still a very important part, is the documentary impulse. One of the things that I have found is that the descendants of the people who are in the African American pictures from South Carolina are very hungry for these images. They are looking at them for a kind of photographic record that just doesn't exist otherwise. I think people either discounted or rejected this work for a while—Peterkin suffered from the same sort of rejection. But I think that reaction is fading, giving way to a realization that the stories and the photographs, both, are something rare and fine.

Chronology

1882

Doris May Ulmann is born in New York City on May 29 to Gertrude and Bernhard Ulmann. Loses her mother in childhood. Father operates a textile business. Develops stomach problems at a young age; in spite of several operations, suffers from this condition until the end of her life.

1900–1903

Studies teacher training at the Ethical Culture School, New York, while Lewis Hine is a botany instructor there. Begins casual use of a box camera.

1907–10

Studies law and psychology at Columbia University, New York. Takes photography classes with Clarence H. White at Columbia Teachers College.

1913–17

Continues photographic studies under White at the Clarence H. White School of Photography, New York. Marries Dr. Charles H. Jaeger, an orthopedic surgeon and professor at Columbia University Medical School who is also an amateur photographer and family physician to White. They live first at 129 West Eighty-sixth Street and then, in the early 1920s, move to 1000 Park Avenue, which will become Ulmann's permanent home and studio. With Jaeger, joins the Pictorial Photographers of America.

1918

Devotes herself full time to photography, especially studio portraiture.

1919

Her first publication, a portfolio of twenty-four portraits collected as *The Faculty of the College of Physicians and Surgeons, Columbia University*, with a foreword by Samuel W. Lambert (New York: P. B. Hoeber), appears under her married name, Mrs. Doris U. Jaeger. Also as Jaeger, exhibits five pictures at the Carnegie Institute in the annual Pittsburgh Salon in the company of Pictorialists such as Laura Adams Armer, Margrethe Mather, Oscar Maurer, D. J. Ruzicka, and Edward Weston.

1920

Ulmann's *Portrait of a Child* appears in the first issue of *Pictorial Photography in America* and in *Photo-Era*. Exhibits with her husband in the Pittsburgh Salon with Alice Boughton, Imogen Cunningham, and Louis Fleckenstein.

1921

A second Ulmann portrait, of an unidentified man, is published in the second issue of *Pictorial Photography in America.*

1922

Thirty-seven photogravures are published in *A Book of Portraits of the Medical Faculty of The Johns Hopkins University* (Baltimore:

The Johns Hopkins Press). The introduction states that the pictures were made in 1920. As author, Ulmann uses her maiden name, suggesting a possible separation from Jaeger by this point. She also exhibits two pictures at the Pittsburgh Salon under her name.

1925

Travels in Virginia, New York, and Pennsylvania to create a series on inhabitants of the Dunkard, Shaker, and Mennonite communities in these states. *A Portrait Gallery of American Editors* (New York: W. E. Rudge), with an introduction by Louis Evan Shipman and forty-three photographs by Ulmann, is published in a limited edition of 375 copies. Divorces Jaeger about this time. White dies suddenly on a trip to Mexico. Ulmann meets John Jacob ("Jack") Niles (1892–1980), an actor, musician, balladeer, and folklorist, at New York's Grand Street Follies, where he is performing in three skits.

1926

Suffers severe knee injury; walks with a cane thereafter. The fourth issue of *Pictorial Photography in America* includes Ulmann's portrait *An Old Virginia Type.*

1927

Niles is employed by Ulmann as her general assistant; as a frequent companion he attends theater, opera, and ballet performances with her in New York. "Character Portraits by Doris Ulmann," with text by Hamlin Garland, is published in the *Mentor* (July). Several of Niles's "Kentucky sketches" appear in *Scribner's Magazine* under the title "Hill Billies," and his World War I collection of the songs of black soldiers is issued.

Doris Ulmann. *John Jacob Niles at the Piano,* circa 1927–34. Platinum print, 15.4 × 20.1 cm. 87.XM.89.15.

1928

Takes the first of at least seven summer road trips with Niles to the South. On this one they visit Louisa, Hazard, and Whitesburg, Kentucky, as well as the Hindman Settlement School in Knott County. Niles meets with Jean Thomas, Jilson Setters ("Blind Bill" Day), and Mosey and Pete Carter to further his collection of American ballads. Ulmann's recent Appalachian subjects are brought to public attention with "The Mountaineers of Kentucky: A Series of Portrait Studies" (*Scribner's Magazine*, June) and "Among the Southern Mountaineers" (*Mentor*, August). The *Scribner's* issue also contains a piece on folk songs, "In Defense of the Backwoods," with an introduction and annotations by Niles. The editors introduce him as someone who "comes from the backwoods himself" and refer the reader to Ulmann's photographs for portrayals of "the sort of people" who sing the songs he collected "back home." Niles begins performing with the singer Marion Kerby, a contralto with whom he will tour the United States and Europe through 1933. Columbia professor Franz Boas's classic text, *Anthropology and Modern Life*, appears.

1929

First solo exhibition, at Delphic Studios, New York. Begins close friendship with the South Carolina writer, actress, and farmer Julia Peterkin (1880–1961). Over the next four years they collaborate on *Roll, Jordan, Roll,* a presentation of African American folklife in the South, inspired primarily by the Gullah residents of Peterkin's Lang Syne Plantation. Visits New Orleans with Peterkin. Peterkin's novel *Scarlet Sister Mary* (1928) is awarded the Pulitzer Prize; Ethel Barrymore contracts with the author for stage rights. *Monday* (pl. 21), an image of a woman at her laundry, appears in the final issue of *Pictorial Photography in America. Scribner's Magazine* publishes Niles's sketches and songs of itinerant vendors in "The Passing of the Street Cry." August Sander's collection of sixty portraits, *Antlitz der Zeit* (Face of the time), is issued in Germany.

1930

Eight portraits illustrate the article "The Stuff of American Drama in Photographs by Doris Ulmann" in *Theatre Arts Monthly* (February). Allen H. Eaton, a field officer for the Russell Sage Foundation whom Ulmann had met through Clarence White, sees her work on exhibition at the Mountain Workers Conference in Knoxville and decides to enlist her help in an Appalachian project. Nine of her portraits of New York literati (including writer/photographer Carl Van Vechten) are published with the article "Doris Ulmann: Photographer-in-Waiting" by Dale Warren in the *Bookman* (October). In November she is one of sixteen artists included in *International Photography,* an exhibition mounted in Cambridge, Massachusetts, by the Harvard Society for Contemporary Art. Charles Sheeler, Alfred Stieglitz, and Paul Strand are also included. Travels to South Carolina to continue work with Peterkin. The photographer Edward Curtis publishes the final volume of his *North American Indian,* a twenty-volume work begun in 1907.

1931

Probably travels to South Carolina to work with Peterkin. Ulmann visits the New Orleans area again, this time with Niles, and works at Melrose Plantation in Louisiana and then in Mobile before returning to New York. Beginning in July, her portraits of authors are published in *Wings,* the magazine of the Literary Guild of America. Emily Clark's *Innocence Abroad* contains four of Ulmann's portraits of writers, including a study of Peterkin, about whom Clark presents a substantial profile.

1932

Works in Tennessee and Kentucky (Whitesburg, Hazard, Cumberland, and Kingdom Come). Agrees to make photographs of Appalachian crafts for Eaton's book *Handicrafts of the Southern Highlands* (published 1937). Five of her photographs are included in the *International Photographers* exhibition at the Brooklyn Museum, along with work by Berenice Abbott, Ilse Bing, Margaret Bourke-White, Imogen Cunningham, Walker Evans, Florence Henri, André Kertész, Tina Modotti, László Moholy-Nagy, Man Ray, Maurice Tabard, and Edward Weston. Ulmann's portrait of an African American grandmother and child appears in the French journal *Etat de la Photographie.* Peterkin and Ulmann perform in *Hedda Gabler;* Peterkin's novel *Bright Skin* is dedicated to Ulmann.

Doris Ulmann. *John Jacob Niles Carrying Doris Ulmann across Cutshin Creek, Near Higdon, Kentucky,* 1933. Gelatin silver print, 20.3 × 15.2 cm. 87.XM.89.21.

1933

Following an itinerary (or "shooting script") worked out with Eaton, Ulmann and Niles travel to Kentucky (Hazard, Homeplace, Quicksand, and Berea), North Carolina (Murphy and Brasstown, where they visit the John C. Campbell Folk School), northern Georgia, Tennessee (Gatlinburg), and Virginia (Richmond). Ulmann's photographs are exhibited at Berea College, where Niles also gives a concert; at the Southern Workers Conference in Brasstown; and at the meeting of the Southern Women's Education Alliance in Richmond. In New York, has a second show at the Delphic Studios. Seventy-two images printed in offset lithography appear in the trade edition of *Roll, Jordan, Roll*

(New York: Robert O. Ballou); a deluxe limited signed edition of 350 copies containing ninety hand-pulled copperplate gravures in a somewhat different arrangement is released in 1934.

1934

The Library of Congress acquires forty prints and exhibits them in February. After visiting this show, Eleanor Roosevelt invites Ulmann to dinner at the White House in the spring; Ulmann attends with Niles, who gives an impromptu performance of folk music. On a trip lasting from April to August, Ulmann and Niles work in Berea, Harlan, Lexington, and Pine Mountain, Kentucky; Brasstown, North Carolina; and in the vicinity of Gatlinburg, Tennessee. "People of an American Folk School," a *Survey Graphic* article on the Campbell Folk School and its adjunct cooperatives, appears in May with four Ulmann compositions. First British edition of *Roll, Jordan, Roll* is published (London: Jonathan Cape). The August issue of *Theatre Arts Monthly* includes a piece called "Within the Type: For a Dramatist's Notebook," containing six Ulmann portraits under the heading "In Southern Hills." Ulmann becomes ill on the road and dies in New York City on August 28. According to her wishes, the Doris Ulmann Foundation is established, with Eaton, Niles, Olive Dame Campbell, Berea schoolteacher Helen Dingman, and Ulmann's brother-in-law as executors. Campbell's tribute to Ulmann is published in *Mountain Life and Work* (October). Hundreds of prints produced by S. H. Lifshey are delivered by Niles to sitters in North Carolina and Kentucky according to Ulmann's habit of sending photographs to her subjects.

Doris Ulmann. *Darkroom Still Life,* 1918.
Platinum print, 20.1 × 15.8 cm.
87.XM.89.27.

Editor	Gregory A. Dobie
Designer	Jeffrey Cohen
Production Coordinator	Stacy Miyagawa
Photographer	Ellen Rosenbery
Printer	C & C Offset Printing Co., Ltd.
	Hong Kong